G000230693

STEVENAGE
THROUGH TIME
Hugh Madgin

AMBERLEY PUBLISHING

Acknowledgements

This book would not have appeared without considerable support from a number of people: the unfailing assistance of Ian and Patricia Aspinall; David Cornell; R. W. James; Kate Johnston, Designer, Stevenage Museum; Neil Langdon; Michael Ludford; Tom Mellett; Mrs Pat Smith; Mary Spicer; Jo Ward, Cultural Services Manager, Stevenage Borough Council; Claire Willetts, Curator, Stevenage Museum and Chris Wills in providing photographs and information has been crucial. To them I would like to record my grateful thanks. Special thanks are also due to my wife Cath for her unfailing support.

First published 2009

Amberley Publishing Plc
Cirencester Road, Chalford,
Stroud, Gloucestershire, GL6 8PE

www.amberley-books.com

Copyright © Hugh Madgin, 2009

The right of Hugh Madgin to be identified as the Author of this work has been asserted in accordance with the Copyrights, Designs and Patents Act 1988.

ISBN 978 1 84868 744 8

All rights reserved. No part of this book may be reprinted or reproduced or utilised in any form or by any electronic, mechanical or other means, now known or hereafter invented, including photocopying and recording, or in any information storage or retrieval system, without the permission in writing from the Publishers.

British Library Cataloguing in Publication Data.
A catalogue record for this book is available from the British Library.

Typeset in 9.5pt on 12pt Celeste.
Typesetting by Amberley Publishing.
Printed in the UK.

Introduction

Stevenage is a remarkable town. Today, it is the second largest settlement in Hertfordshire, behind only Watford in size. It is, however, much more than a single large entity: it manages simultaneously to be a deserted medieval village, a market town, and that most emblematic of mid-twentieth century creations, a New Town.

The area which Stevenage now occupies has evidence of human activity stretching back 250,000 years, when an early form of homo erectus left a flint axe at what is now Fishers Green. There are also many archaeological remains from intervening eras, and the original settlement of Stevenage, on rising ground three quarters of a mile east of the Roman road which now forms Stevenage High Street, dates from the Saxon period.

Called Stigenace ('strong oak') in the eleventh century, this area, where the parish church of St Nicholas stands, is truly 'Old Stevenage'. It became a deserted medieval village around the time of the thirteenth century, when the town of Stevenage was laid out upon what is now Stevenage High Street, but the church remained at the old site (as it still does today), along with a few houses, including the ancient Old Bury.

The town of Stevenage can be said to date from around 1223 when there is the first record of a market being held; the population of the town is reckoned to have remained roughly constant at around a thousand (ten times that of the old village) until the expansion of the nineteenth century. Today, this 'Mark 2 Stevenage' is often rather unfortunately referred to as 'Old Stevenage' as a result of the building of 'Stevenage Mark 3' – the New Town constructed after the Second World War.

Owing to its creation as the first of the satellite towns around London under the New Towns Act and, like its eighteenth century counterpart in Edinburgh, which still keeps the 'New' epithet, Stevenage New Town will always be referred to as such, although now, in the twenty-first century, it is, of course, far from new in reality.

The New Town is indeed a fascinating monument to the planning and social idealism of the middle of the last century, and today is of enormous interest to the student of architectural and planning history. Undoubtedly, some aspects of the New Town have been of questionable merit – the 'first pedestrianised town centre', opened by the Queen in 1959, with its narrow precincts and uneasy atmosphere after the shops have closed, may not, with the advantage of hindsight, have been the best way to build for the future, but the overall benefit to the tens of thousands of people who were given a new start in Stevenage is a worthy memorial to the planners of the 1940s and 1950s who wanted to make a clean break from the past.

With the exception of the village green of Shephall, almost every building which had existed in the area of the New Town before 1950 was demolished, but care was taken to leave as many of the existing trees and hedgerows as possible. These, along with tens of thousands of trees planted since the 1950s, and the retention of nearly all the old, established areas of woodland across Stevenage, mean that, contrary to the stereotypes of unrelieved concrete, nobody in Stevenage is ever more than a few yards from a green area.

Undoubtedly, the transformation after the Second World War from a town of under 7,000 population to one of 80,000 today has seen the greatest changes in Stevenage. However, the pre-1940s town was far from static – once the railway opened in 1850, the town was on a constant trajectory of expansion, its population of 1,254 in 1801 having risen to 3,958 by 1901. All places change through time; even the most remote village cannot remain preserved in aspic. Stevenage, with its station on the East Coast main line railway and its location on the Great North Road thirty-two miles from London, was always going to change more than most.

Hugh Madgin
Stevenage, 2009

About the Author

Hugh Madgin has relished looking into the history of Stevenage all his life. He is the creator of stevenageonthenet.com.

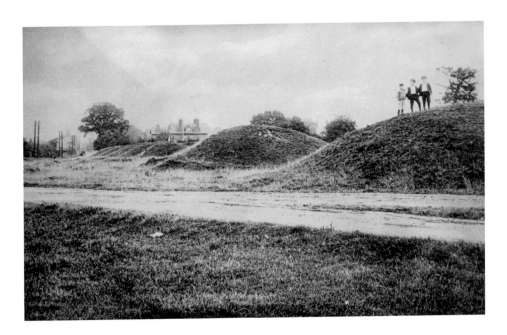

Six Hills

The oldest man-made feature of Stevenage is the Six Hills, a line of tumuli which stands alongside London Road a mile to the south of Stevenage High Street and very close to the New Town Centre. The mounds are believed to be Romano-British, but the precise details of their origin are probably beyond certain proof. The nearest house behind the hills in the earlier view is Daneshill, its name suggesting another possible origin of the barrows. It was the home of J. Marsden Popple, who gave the town the land to form its King George V Playing Fields. Although it was demolished when the New Town Centre was built, a number of its trees survive, including some rare Mediterranean coastal pines, which have given their name to the Pinetree Court retirement complex. *Stevenage Museum/P136*

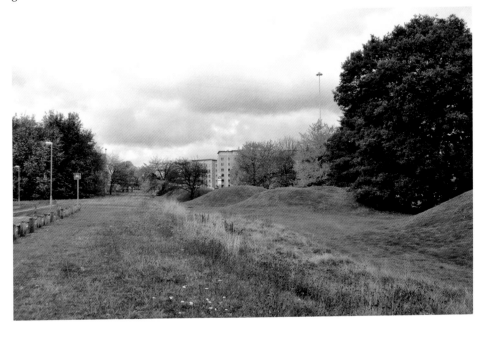

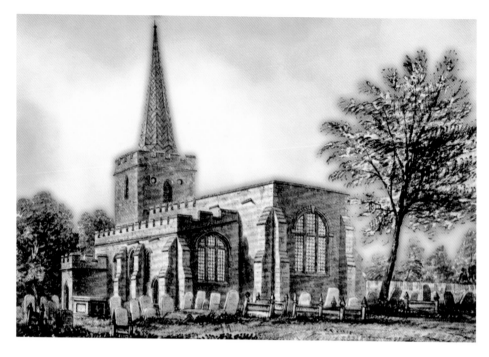

Stevenage – The Village

While Stevenage moved down to the main road to become a town in the thirteenth century, the church, dedicated to St Nicholas, remains at the site of the deserted medieval village. After extensions to the old building to accommodate the rising population, a chapel of ease, Holy Trinity, was built in the town in 1861. Today, St Nicholas is parish church for only a part of Stevenage.

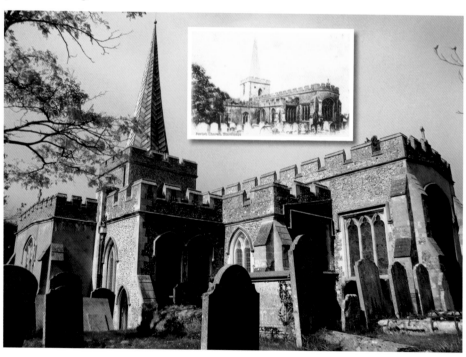

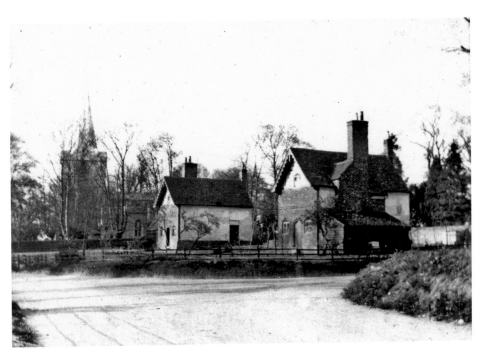

Church End
The area around St Nicholas was at one time called Church End, but this name fell out of use around 100 years ago. There are just half a dozen houses around the church, including the two timber-framed buildings seen here.

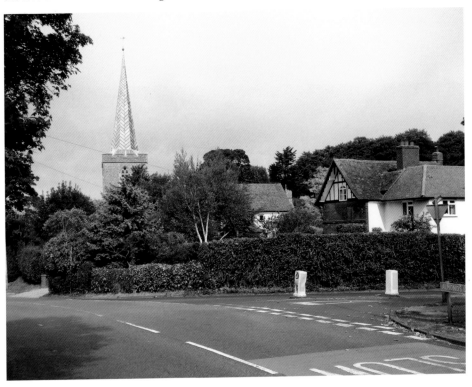

Church Lane

The old settlement of Stevenage was connected to the market town by Church Lane. Most of this ancient thoroughfare survives, except where a dog-leg was introduced when the fields of Stevenage were enclosed in the 1850s. The section of the old lane in these views is now part of Rectory Lane, the mature trees leading to the left in the middle distance in the earlier picture were superseded by an extension of The Avenue in the 1930s.

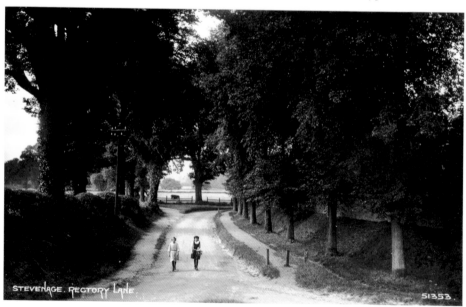

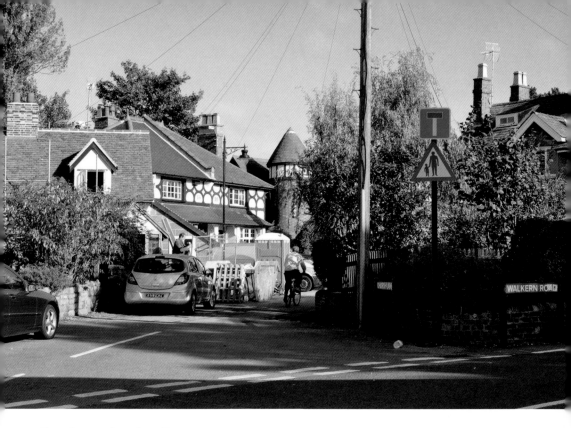

Church Lane *(continued)*

At the town end of Church Lane stands a group of picturesque buildings. Alongside traditional cottages there are some notable houses built by Stevenage's first historian E. V. Methold in the late nineteenth century, including the Tower House and a pair of hipped-roof semis which anticipate 1930s styles by forty years.

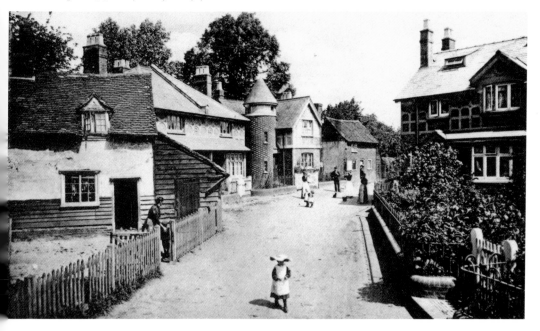

Stevenage – The Town

The town of Stevenage was laid out in the 1200s along the Roman road that now forms Stevenage High Street. Its north end was at the fork where the routes to Hitchin and Baldock diverged. The land between the two diverging roads was a bowling green, where Samuel Pepys once played. Unfortunately, the infamous Road 10 scheme of the 1970s swept away this pivotal part of the layout of the town, and today, only the eastern half of the fork survives, as part of a gyratory system.

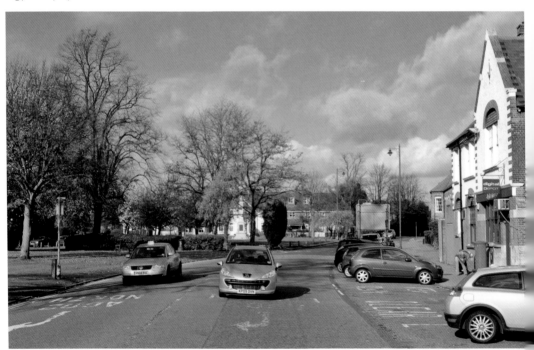

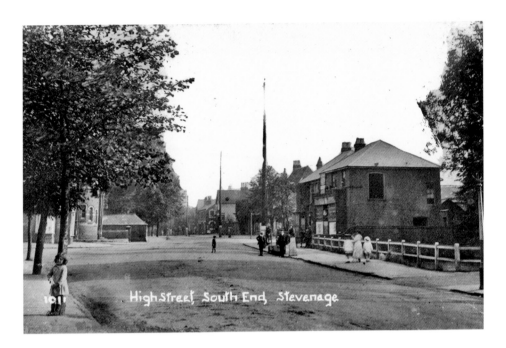

High Street, South End

High Street, South End

While the name North End for the top of the High Street fell out of use in the early nineteenth century, the bottom end was known as South End until recent times. The High Street ended at a crossroads where Sish Lane ran to the east and Trinity Road ran to the west. As with the junction at the Bowling Green, the crossroads was replaced – by an elevated junction and underpass – in 1976. The buildings on the right in the upper picture were Ayres Grocers and more recently part of the garage of the Stevenage Motor Company before a spell as part of a B&Q outlet, before demolition in 2008. A new development, with the appropriate name of Townsend Mews, was under construction at the time of writing.

Market Place

The central section of the High Street looking south. Although the upper picture is not of the best quality, it is of great interest as it is the only known view showing the market place area before the large building erected by Mr Adams appeared at the end of the nineteenth century, in front of the white-gabled building seen in the left-hand middle distance. The white gable on the right-hand side of the road is that of the White Lion Hotel, the town's principal coaching inn; the pillar-like structure – complete with prop – is the town's fire bell, erected in 1887.

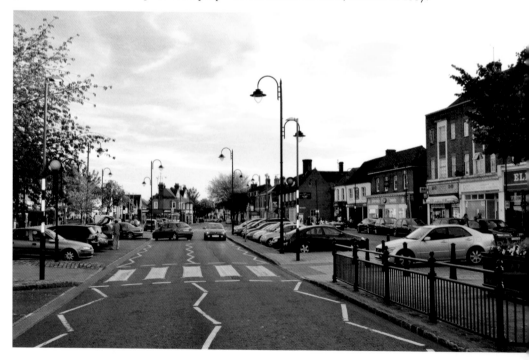

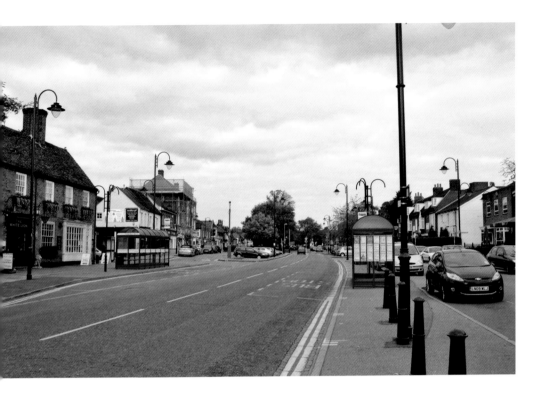

Market Place (continued)

Charles Dickens famously lambasted Stevenage for being 'drowsy to the dullest degree' after passing through the town on a visit to an unwelcoming James Lucas, the Hermit of Redcoats, in 1861. Stevenage was actually thriving at the time, but in this view taken a few years later, his slur might appear to have some credance. More than 140 years later, a Sunday morning can still give the same impression of wide, open space.

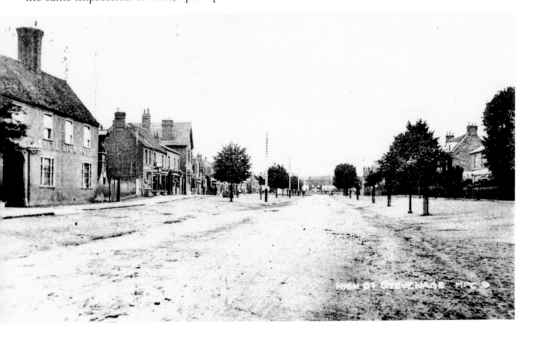

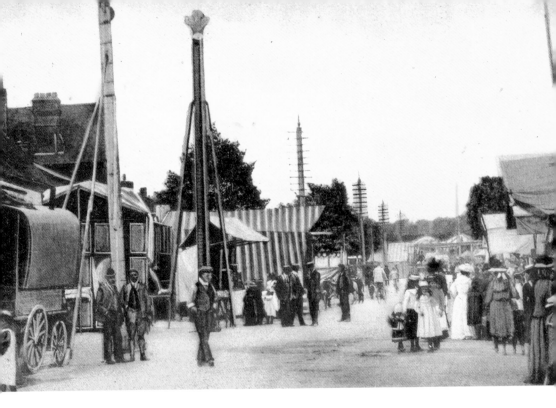

Stevenage Fair

Stevenage's market has come and gone over the centuries, and the market place in the High Street has been market-less since 1961. Stevenage Fair, however, now well into its eighth century, continues each year, on 22 and 23 September, attracting crowds of many thousands. By the late nineteenth century, the fair had, like virtually all others nationwide, become primarily a pleasure fair although the last trader, a china stall, continued five years into the twenty-first century.

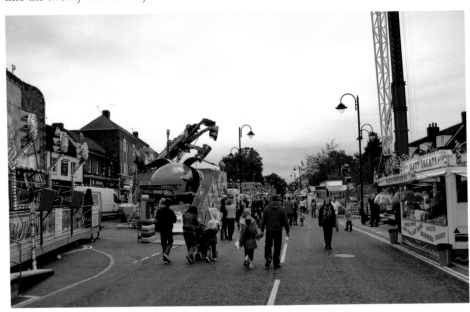

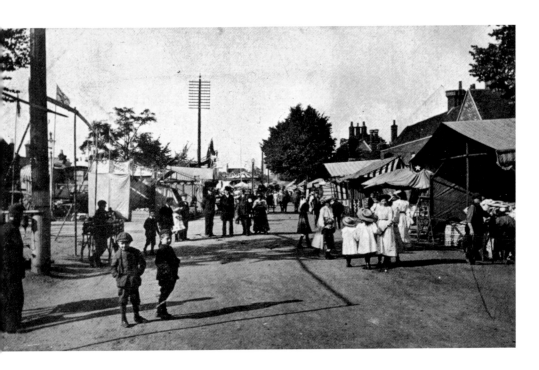

Stevenage Fair *(continued)*

The showmen who attend Stevenage Fair have a long and interesting history that is overlooked by the uninitiated. Tony Smith, whose Crooked Cottage is on the right of the 2009 picture, occupies the same spot as his great-grandfather did in the earlier picture of 1907.

High Street

By the time of the First World War, the High Street had received massive telegraph poles in place of the more modest ones first erected in the 1880s. Mr Adams' horticulture business in the building to the left had been replaced by the cycle shop of T. Palmer, while the White Lion had entered the motor age, with a garage complete with inspection pit in its yard. Petrol was sold at the hotel, from cans.

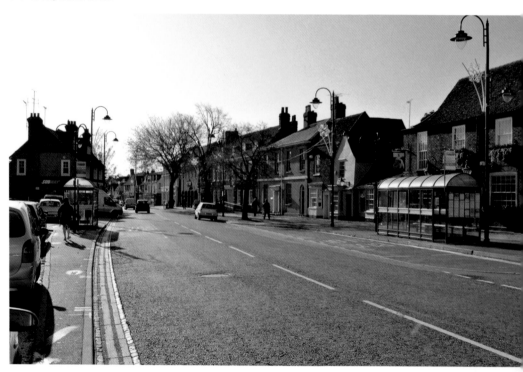

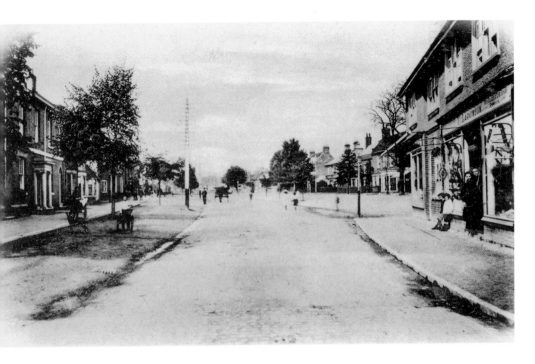

High Street Looking North

Larkinson's shop (right) is today commemorated in the name of a modern residential road. Larkinson's produced postcards, one of which is reproduced on Page 22. The elegant early nineteenth-century house opposite – Wye Lodge – is one of several in the High Street that acquired names referring to places in the Welsh border counties in the 1800s.

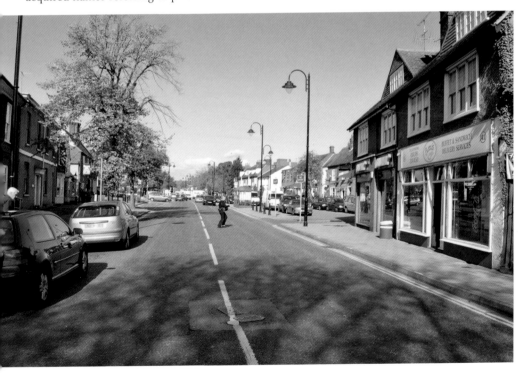

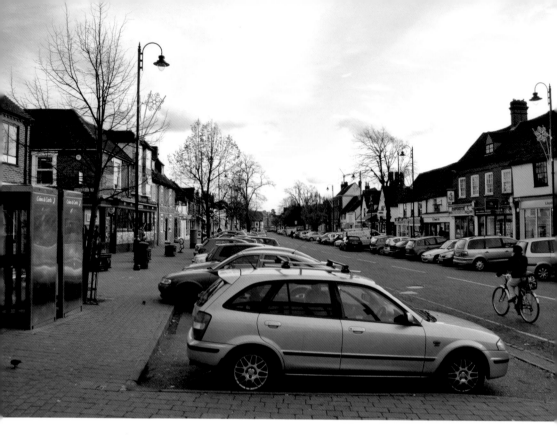

High Street

The southern half of Stevenage High Street, showing, on the left, the entrance to Albert Street. The extension of Albert Street into the High Street in 1859 required the demolition of the Windsor Castle pub. The single-storey shop, two doors down from the corner, with a large white fascia board, was the location of Stevenage's first fish and chip shop, run by the Furr family. It burnt out in 1916.

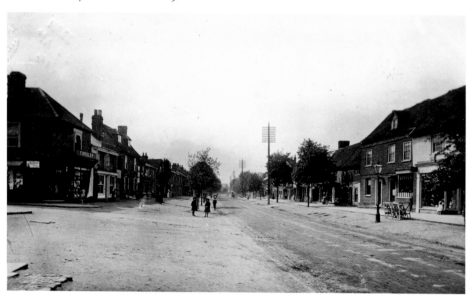

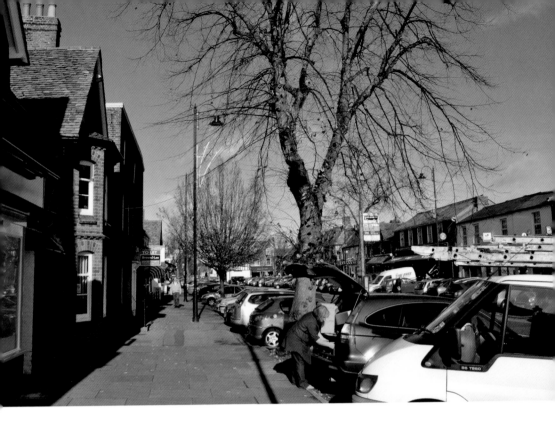

High Street *(continued)*

The large Georgian-fronted house on the left escaped conversion to plate glass windows for its ground floor between the wars when planning permission was granted, but then allowed to lapse. The garage of Shelford & Crowe had petrol pumps on the highway in the 1920s; a motorcycle combination is receiving a refill.

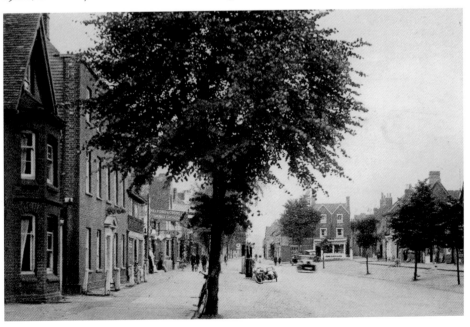

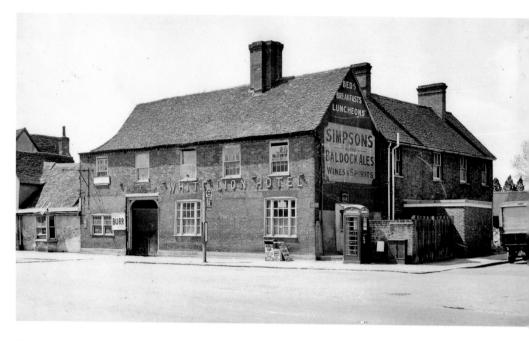

White Lion Hotel

The low-roofed part of the White Lion, to the left of the brick frontage, dates back to medieval times and is the only building left in the High Street to display the proportions that the very first buildings of the 1200s would have exhibited. Major rebuilding, seen here in progress in the upper picture, took place in 1962, when the gateway was filled with a new main entrance. *Stevenage Museum/PP599*

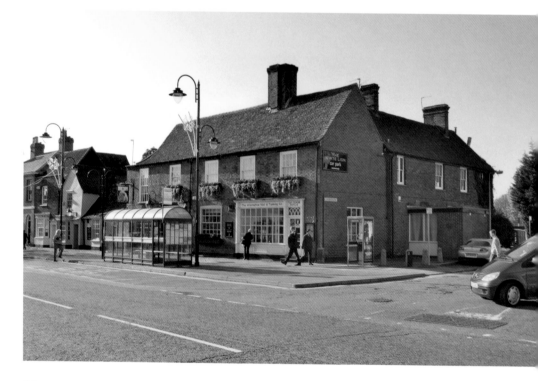

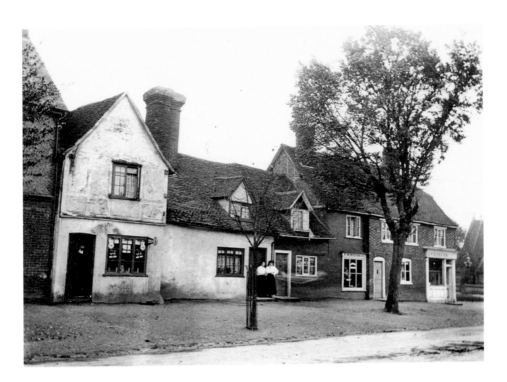

George & Dragon

The George & Dragon, with its gabled cross-wing to the left, closed as a pub in the first decade of the twentieth century. The upper view shows it shortly afterwards, with the two shops of the Steers family on its south side. Rather strangely for a timber-framed building, the old George has in recent years acquired mock timber framing on top of its plasterwork.

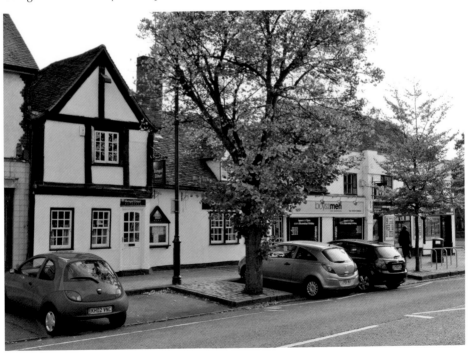

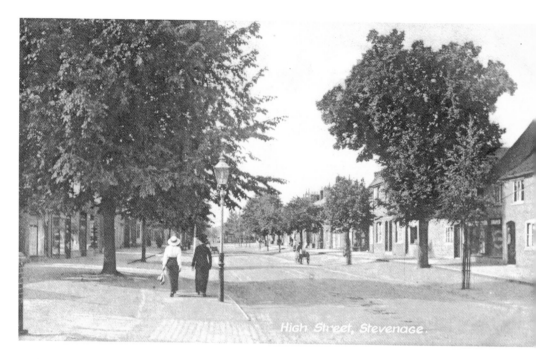

High Street, Stevenage.

High Street, South

Towards the lower end of Stevenage High Street, looking north. The saplings are the lime trees of the Jubilee Avenue, planted at the instigation of John Bailey Denton to mark the Golden Jubilee of Queen Victoria in 1887 (and to mask the telegraph poles installed in 1883). These trees were planted all the way from the Bowling Green to the Six Hills. Eleven remain today.

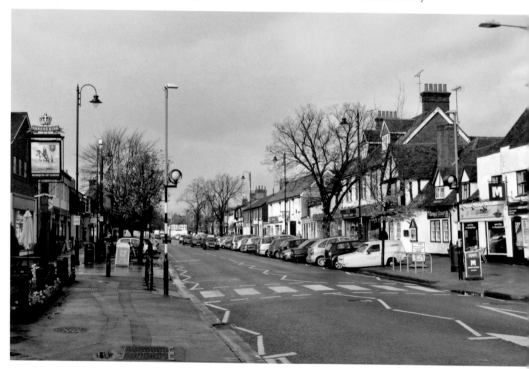

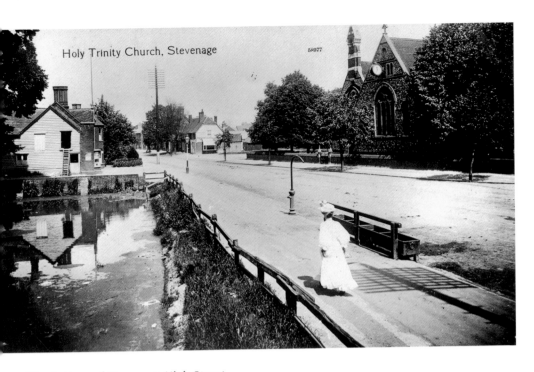

Holy Trinity Church, Stevenage 58077

The Bottom of Stevenage High Street

On the left is the Weir Pond, the last to survive of several in the High Street, being filled in in 1933. Over the road stands Holy Trinity church, built in 1861 and greatly extended twenty years later. Part of the Townsend Mews development stands on the site of the pond.

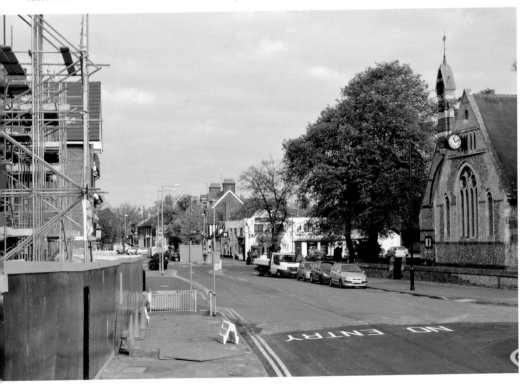

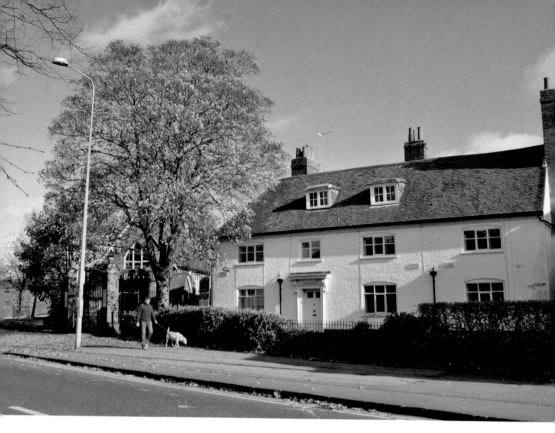

Alleyne's School

At the very north end of the High Street, where it runs into North Road, stands the Thomas Alleyne School, which dates from 1558. A comprehensive school since 1969, it went co-educational from 1989 and at the time of writing is planned to be moved to the Great Ashby area of Stevenage. To the left of the school gates can be seen the entrance to The Avenue.

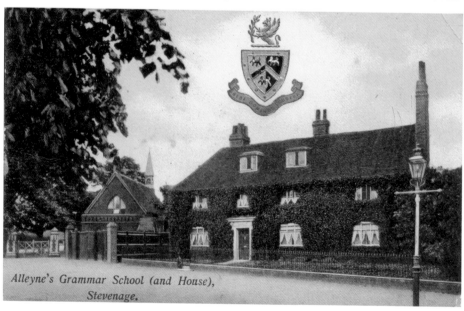

Alleyne's Grammar School (and House), Stevenage.

The Maltings

For nearly thirty years, Stevenage was synonymous with engineering excellence thanks to the establishment of the Vincent HRD motorcycle factory in this former maltings building next to the Thomas Alleyne School. By the time the upper photograph was taken in 1962, the former showroom was used as a studio for sculpture by Martin Wagstaff, an Alleynes pupil in the Lower VI Remove; the building firm Stevens & Barrett occupied another part. By 2009, the old maltings building was out of use, requiring some repairs, pending which scaffolding had been erected to support the structure. *Stevenage Museum/PP608*

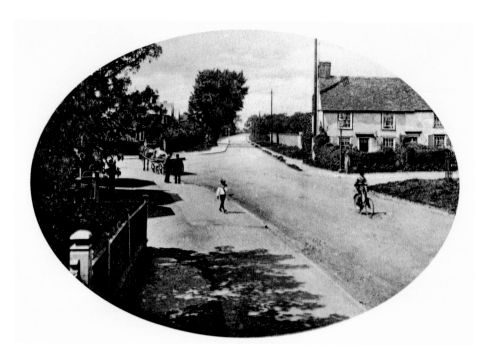

Hitchin Road

The route of Hitchin Road northwest away from the Bowling Green. Hitchin Road is today a dual carriageway, but its exit from the High Street was closed by the Road 10 (Lytton Way) scheme in 1976. In the lower picture some chevrons on a sign at the Hitchin Road roundabout are just visible through the bushes. The white house, No. 1 Bowling Green, was one of the homes of Stevenage MP Barbara Follett in the late 1990s.

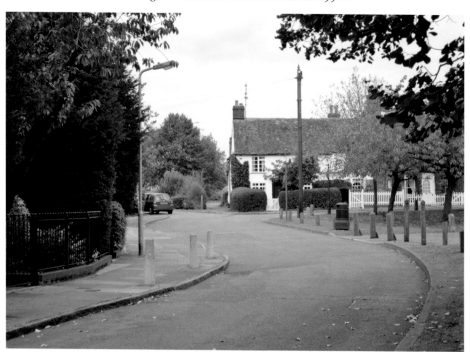

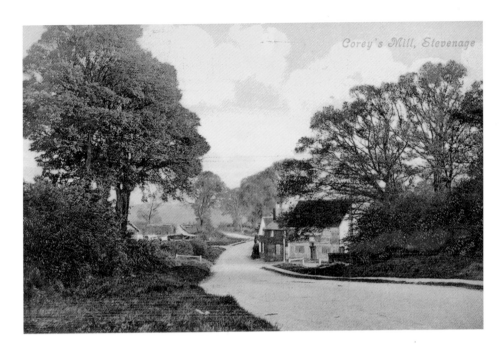

Corey's Mill, Stevenage

Hitchin Road *(continued)*

The pub at Coreys Mill (known as the Windmill, then the White Horse and finally, from the 1960s, The Mill) had just a few cottages for company in 1900. Today, it is adjacent to the Lister Hospital, new housing developments and a Sainsbury's superstore. In addition to being much wider, Hitchin Road has been diverted in the middle distance to a course east of its old alignment, which is now occupied by a road maintenance depot.

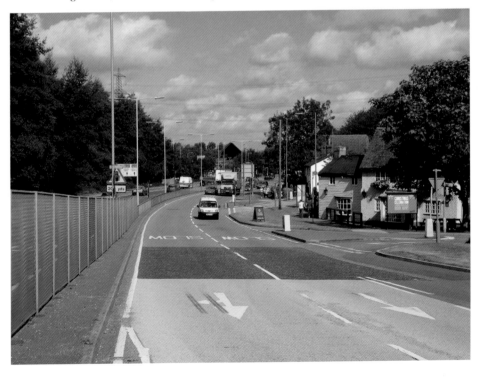

BALDOCK ROAD, STEVENAGE

North Road

North Road, close to The Granby pub. There was a toll bar here during the coaching era, when the roads were greatly improved by turnpike trusts. The pub (formerly the Marquis of Granby) is still with us, but most of the cottages seen on the left-hand side of the road have gone. This area was once known as Saunders Green; the upper view dates from before major improvements to the road in the 1920s, a few years after it was designated the A1 trunk road.

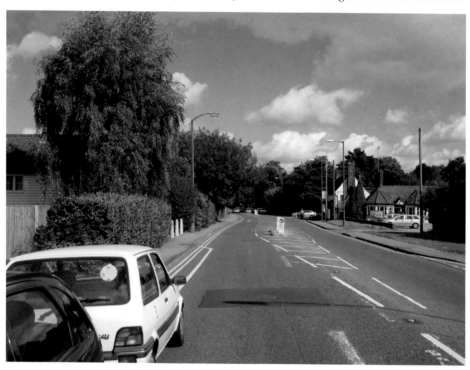

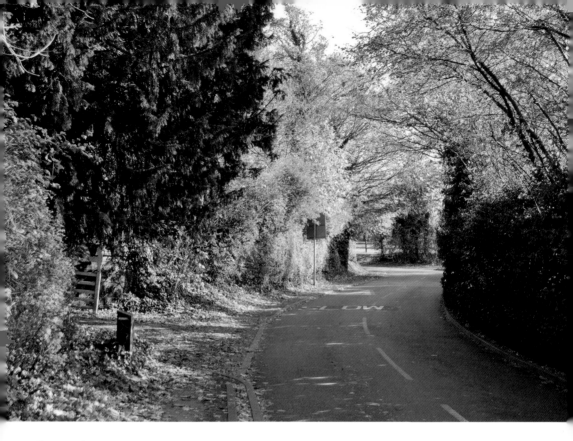

Rectory Lane

Rectory Lane provides an access to the site of the old village of Stevenage from the north west, the curve in the near distance leading to the stretch of road depicted on page 8. With grass covering the surface of the lane, it seems difficult to believe that about forty years after the lower photograph was taken the southbound traffic of the A1 would pass this way when Stevenage High Street was closed during the Fair.

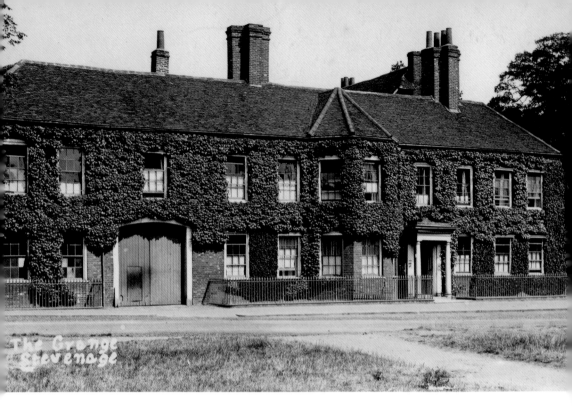

The Grange

Both Samuel Pepys, who stayed here when it was the Swan posting house, and E. M. Forster, who spent a brief and unhappy time as a pupil when it was a private school, are amongst the notables associated with this building. Given the name The Grange when it became a school, No. 5 High Street was the Divisional Education Office for Hertfordshire County Council and Register Office in the 1970s.

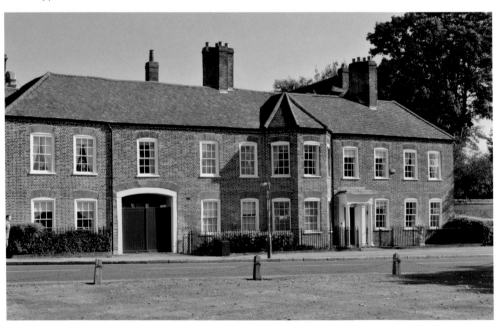

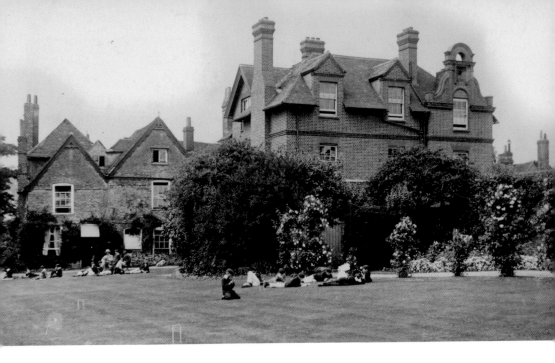

The Grange *(continued)*

The upper view shows the lawn at the rear of The Grange school; the three-storey block on the right housed Alleyne's School Sixth Form from the 1960s to the 1980s. In the 1990s, the premises were sold off for residential development and became The Grange and Olde Swann Court.

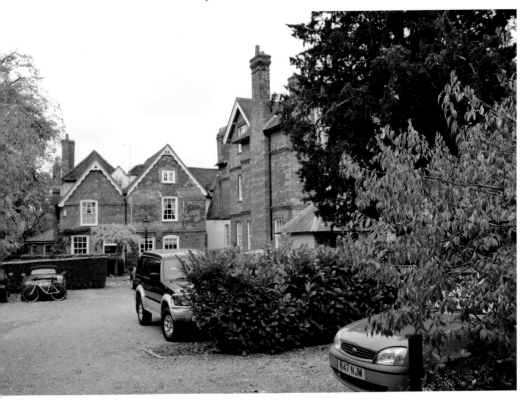

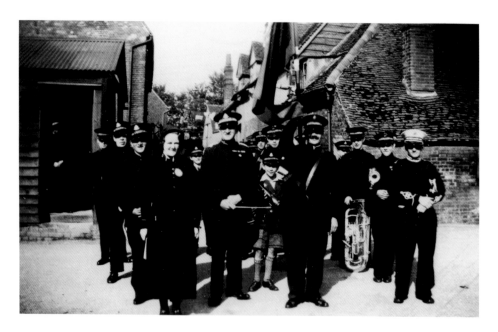

Baker Street

Before 1859, when Albert Street broke through to the High Street, the small thoroughfare, which is now known as Baker Street, was the only break in the buildings on the east side of the High Street between the market place and Shepherds Alley. The Salvation Army had a wooden hall at the corner with Back Lane (now called Church Lane) in the 1920s and its band is shown in the upper view. *Stevenage Museum/PP1105*

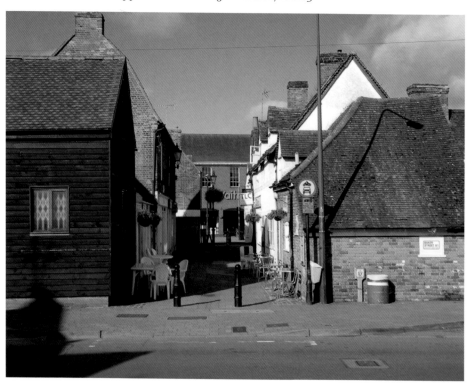

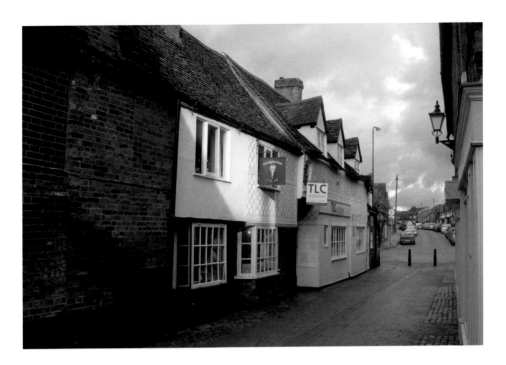

Baker Street *(continued)*

Baker Street looking east towards Grove Road. This street became known as Baker Row in the late nineteenth century, probably because of Pettengells bakery at the western end of the street. The earlier view dates from 1948 when the cottages were still inhabited. No. 2 Baker Street (with the right-hand bay window) is of special note, as this was the home of the heroic George Gaylor, Stevenage's first citizen to be awarded the George Medal. *Stevenage Museum/P3459*

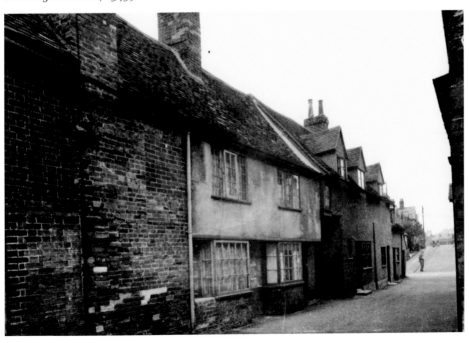

Letchmore Road

No. 2 Letchmore Road has seen many uses during its long history – workhouse, plait school, gas company offices, Conservative club and architects' practice. The upper view shows it in the early twentieth century and parts of the Stevenage Gas Company buildings can be seen in the background. A private house for many years until the late 1980s, it kept gas lighting until receiving a major makeover.

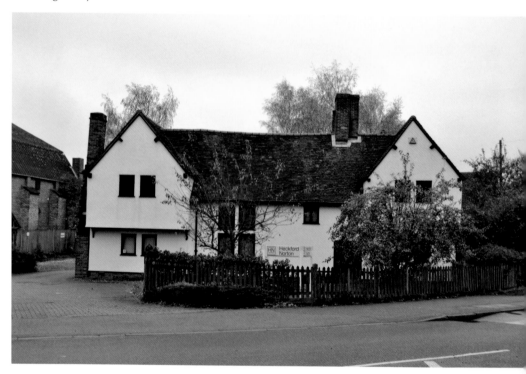

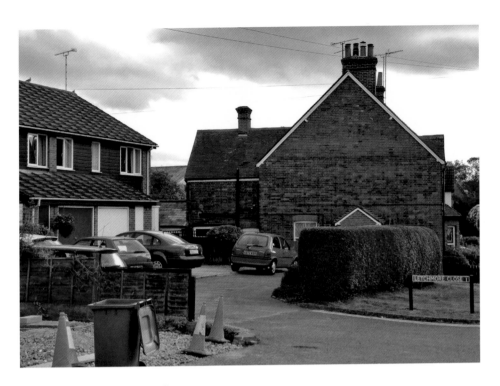

Letchmore Road *(continued)*

The last thatched house in central Stevenage was No. 18 Letchmore Road, demolished in 1971. It was already in existence by 1742, when it belonged to John Newman. For many years occupied by the Mardlin family, it was replaced by Letchmore Close. The brick house to the right is part of a Victorian development of four houses originally known as Trafalgar Square. *Stevenage Museum/P5804*

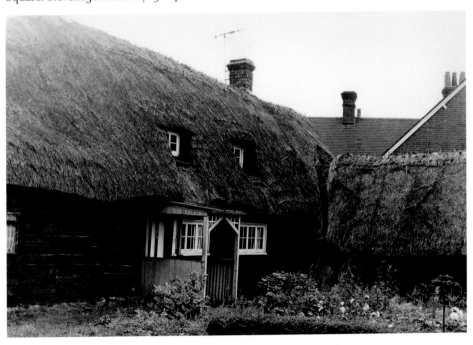

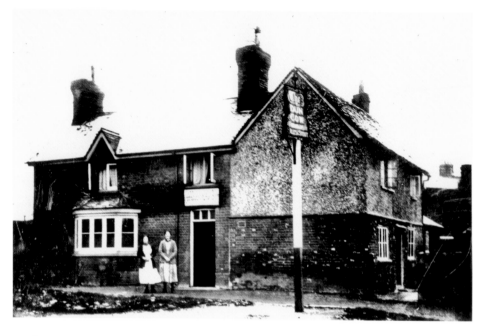

Letchmore Green

Prior to the construction of Albert Street, Letchmore Green had more of its own identity, with small wooden cottages alongside a common. Today, the only building with any pre-Victorian parts on Letchmore Green is the Dun Cow. In the upper view, dated 23 December 1920, licensee Jessie Gardner stands on the left. The bedrooms appear to be receiving a good airing. *Mrs P. Smith*

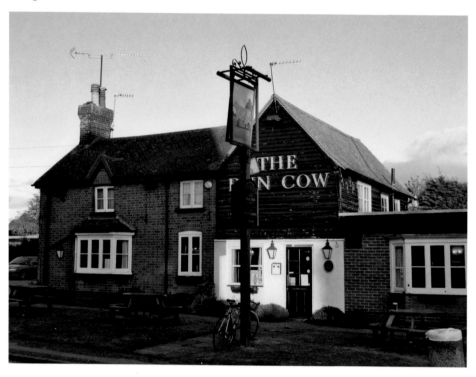

Coronation Cottages

Over the road from the Dun Cow stood Coronation Cottages. These were demolished when Victoria Close was built alongside the Albert Street redevelopment, around 1970. Rather confusingly, a row of four cottages in Fishers Green Road, where Barry Court now stands, was also known as Coronation Cottages just after the First World War. *Stevenage Museum/ P5806*

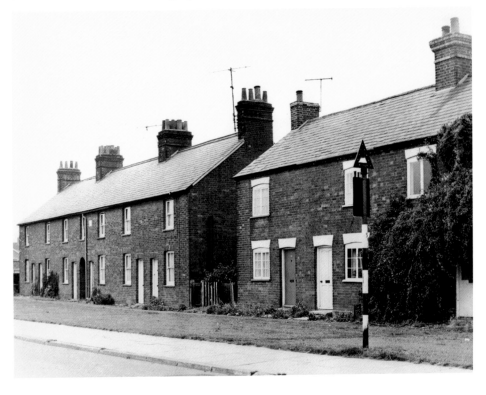

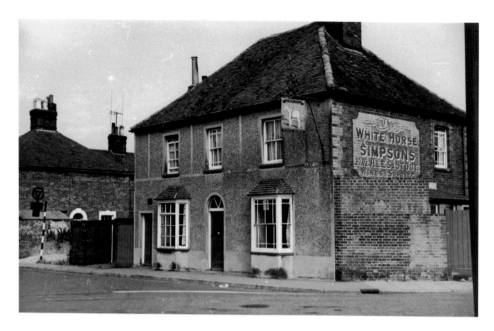

Albert Street

When Albert Street was demolished and rebuilt in the 1960s and early 1970s, its two surviving pubs, the Prince of Wales and the White Horse, were allowed to remain, along with a small range of buildings including Smeeton's fish shop. The upper view shows the White Horse in the 1960s when Sid Jackson was the licensee – remarkably he was a teetotaller. After a short period of closure, the White Horse reopened in July 2009 and is pictured below with its Letchmore Road neighbour, the Dun Cow, in the background. *Stevenage Museum/P8572*

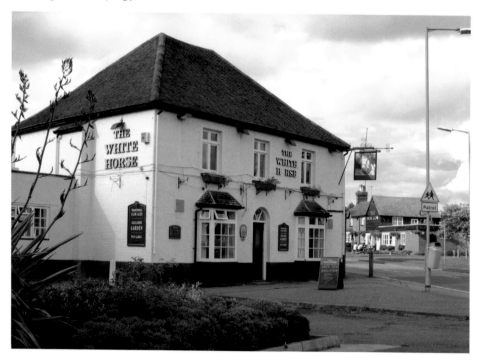

Albert Street *(continued)*

When first laid out in 1852, Albert Street ran from Back Lane to Letchmore Road and was extended through to the High Street (to the left) seven years later. The lower view shows Chittenden's furniture shop in 1970, shortly before demolition and widening of another section of Church Lane. Church Lane, south of Walkern Road, was called Back Lane until comparatively recent times: this road provided access to the rear of premises on the east side of the High Street. *Stevenage Museum/P4419*

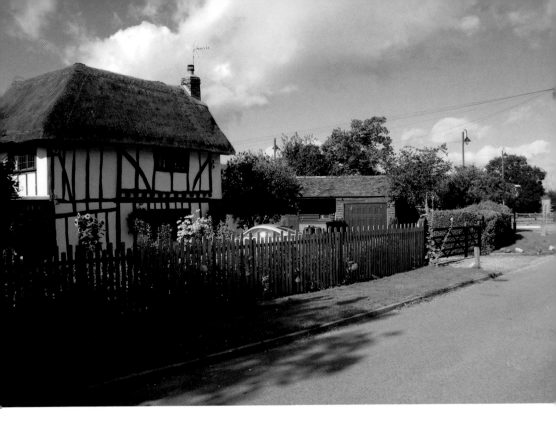

Todds Green

On the northwest boundary of the area covered by the Borough of Stevenage is the hamlet of Todds Green. This thatched house, part of whose plot falls within Stevenage and part of which does not, and which at one time was known as Rats Cottage, was extended and renovated after the Second World War. For many years it was the home of the Hitchin Girls' Grammar School headmistress from 1919 to 1945, Miss Chambers, and afterwards the school's games mistress, Miss Squire.

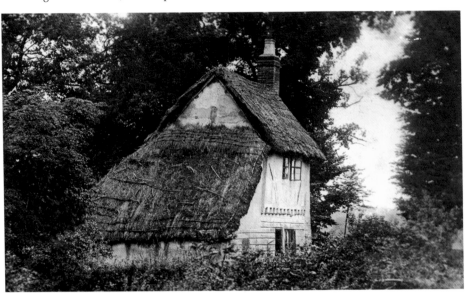

Fishers Green

Just one field back towards the town from Todds Green (today the A1[M] Stevenage Bypass cuts between the two) is the hamlet of Fishers Green, which retains its common. Stebbing Farm can be seen across the common in the upper view; its buildings were converted into housing in the 1970s. While the footpath has not moved, the road across the common has been rerouted to connect with Clovelly Way.

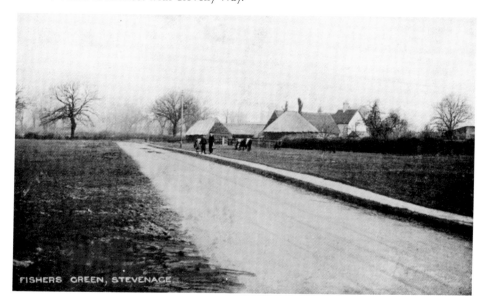

FISHERS GREEN, STEVENAGE

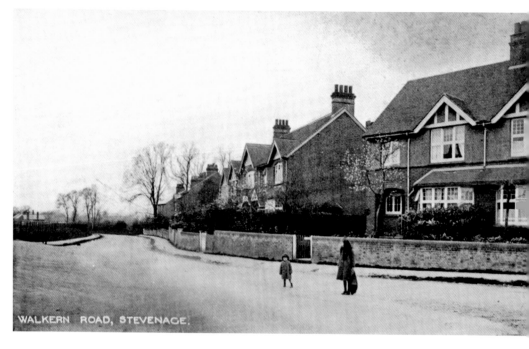

Walkern Road

The principal road eastwards from Stevenage has always been Walkern Road. Its junction with Letchmore Road and Weston Road was known as Four-One Way, although today this no longer applies as Weston Road has been blocked off. The upper view shows Walkern Road before the council houses of the interwar period had been built; Springfield, the largest of the houses built by E. V. Methold, can be seen in the distance.

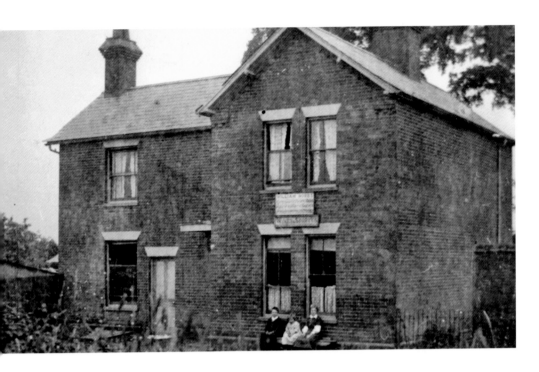

Pin Green

Travelling eastwards from Stevenage, the only hamlet one would pass through before reaching Walkern was Pin Green. Entirely demolished in the 1950s and 1960s, this small settlement boasted a pub, the Three Horseshoes, seen here in 1895. Popular with motorcyclists in the early 1960s, it was replaced by the King Pin in Archer Road and its site is now occupied by the pavilion of Hampson Park, the tarmac in the foreground being the roadbed of Walkern Road. *Stevenage Museum/P852*

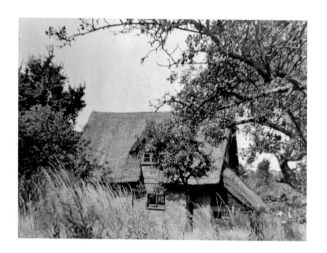

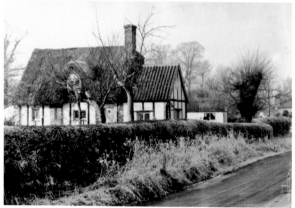

Symonds Green

The very last thatched building in the old parish of Stevenage is this house at Symonds Green. After a period standing empty, it was purchased by R. W. James in 1947 and carefully restored as seen in the second photograph, which dates from 1956. It has since been extended and is now surrounded by modern houses, but it remains a very attractive building. *R. W. James*

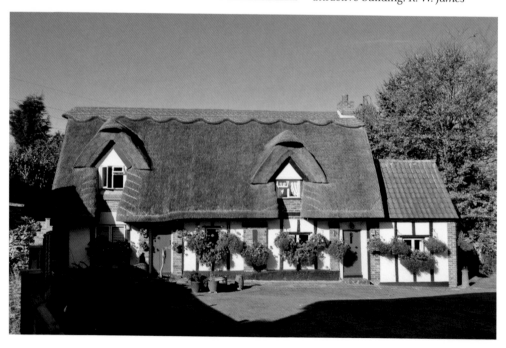

Symonds Green *(continued)*
The lush fields between Symonds Green and Fairview Road were built on in the 1970s. In the lower view part of the ESA factory can be seen in the middle distance, while the roofs of Nos. 52-58 Fairview Road can be seen on the right. Today, the houses of Brixham Close, seen here beyond the dual carriageway Gunnels Wood Road, obscure the view to Fairview Road. *Stevenage Museum/PP60*

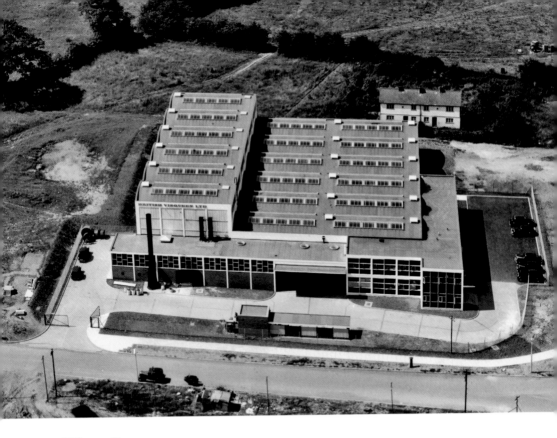

Wilmore Common

Wilmore Common is one of Stevenage's 'lost' places. There were just two cottages here off an ancient lane that headed west from London Road to Norton Green. The lane, Breaches Lane, lost its connection with London Road when the railway was made into four tracks in the 1890s, but these isolated houses survived until the building of the Industrial Area in the 1950s. This aerial view, showing the newly-completed British Visqueen factory in 1954, is the only photograph showing them that has come to light. Today, the site of the cottages is hard by the Council recycling depot. *Stevenage Museum/P13277*

Moving the Boundaries

The coming of the New Town prompted many boundary changes as parts of other districts were taken into Stevenage. The whole of Shephall parish, including the settlement of Broadwater, became part of Stevenage from 1953. Prior to that travellers north along London Road entered Stevenage by the small wood of Warren Spring. This sign was a few yards north, by the entrance to Langley Siding, a goods facility on the railway. The siding remains today, used for trainloads of aggregates, and this part of London Road remains a busy highway, even though it is no longer the A1. *Stevenage Museum/PP931*

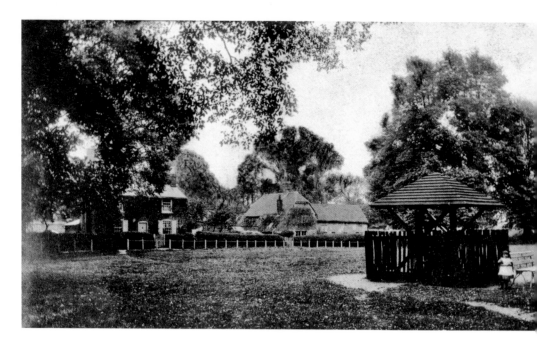

Shephall

Contrary to the intemperate remarks of Dickens, Stevenage was never a sleepy backwater. The village of Shephall was, with its attractive green and ancient church, and lay at the end of a turning off a turning on the main road at Broadwater. Direct connection with Stevenage 'as the crow flies' was by country paths, not metalled roads, and the village, described eloquently by Shephall historian Mary Spicer, was as close to a rural idyll as you can get in the real world. Shephall Green survives, surrounded by the estates of the New Town, and the appearance of graffiti around Stevenage a few years ago in a New York-style hand declaring the existence of the 'Shephall Massive' had a strange poignancy.

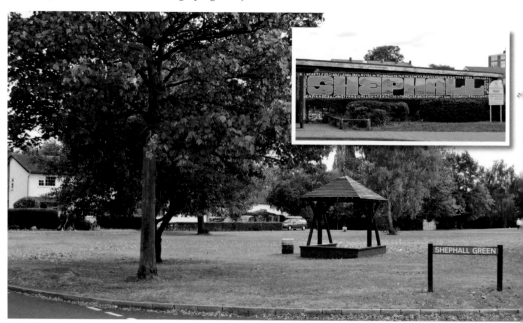

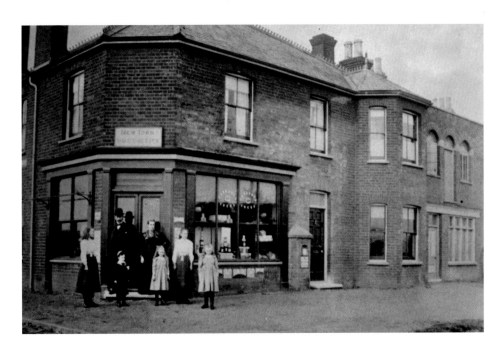

'New Town'

Stevenage's first large factory, Proctor's, opened close to the station at the start of the 1880s; three years later it was taken over by the Educational Supply Association (ESA), which would remain for 104 years. In 1887, plans were put in place for a residential development between the railway station and Fishers Green. Originally called the Station Estate, the development came to be called New Town, although fifty years later this name would be dropped when the statutory New Town was hatched. New Town post office remains today in Fishers Green Road, converted into flats. *Courtesy David Cornell*

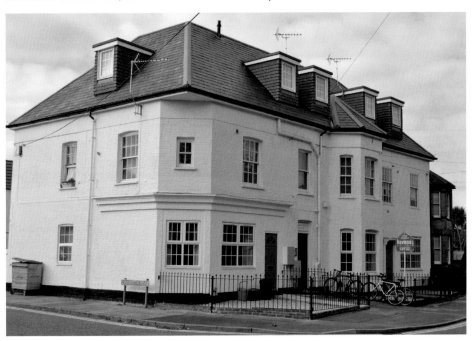

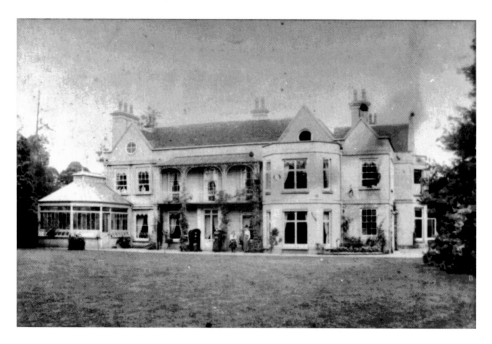

Bragbury End

Bragbury End at the south-eastern tip of Stevenage was formerly part of Datchworth parish and was dominated by the large Bragbury House. Used as a social facility by British Aerospace in the 1960s through to the 1990s, the house has now been converted into apartments. Its large lawns have long since vanished under a realignment of the Hertford Road. *Stevenage Museum/P3158*

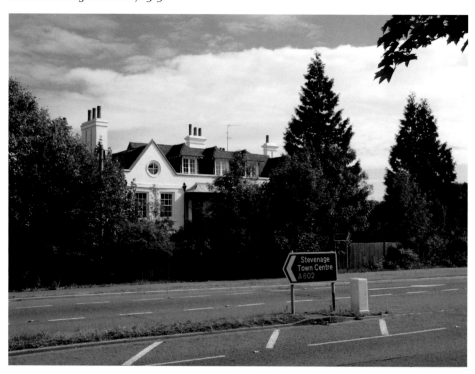

Bragbury End *(continued)*

Bragbury End Farm *c.* 1940. As recently as the 1950s, the cows from the farm at the White Lion Hotel would be walked the three miles down London Road and the Hertford Road (the A1 and A602 respectively) to be serviced by the bulls of farmer Bobby Gray here. Today, after use as a garden centre, the site is being developed as Pembridge Gardens. *Stevenage Museum/P2460*

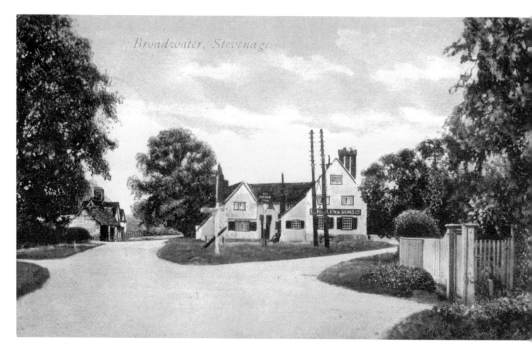

Broadwater

Prior to the 1950s, the hamlet of Broadwater consisted of a farm, around a dozen cottages, a sub-post office, a coal merchant, a blacksmith and the Roebuck Inn. Situated in the 'V' of the junction between the roads to Hertford and London, the Roebuck was the destination each year for the annual holiday of the headmaster of Alleynes between 1915 and 1945, J. P. Thorne, who would spend a fortnight all of two miles away from home.

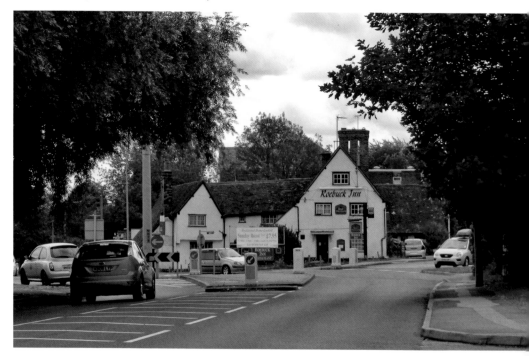

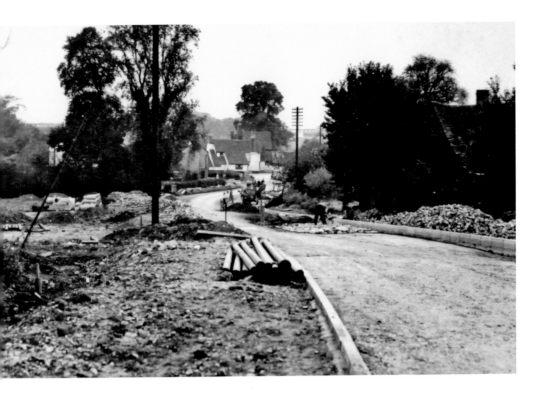

Broadwater *(continued)*
Broadwater gave its name to one of the six 'neighbourhoods' drawn up under the Master Plan of the New Town. Development work began in the early 1950s and the lane from the old Broadwater to Aston, from which Shephall was reached, was upgraded around 1953 and named Roebuck Gate. *Courtesy Michael Ludford*

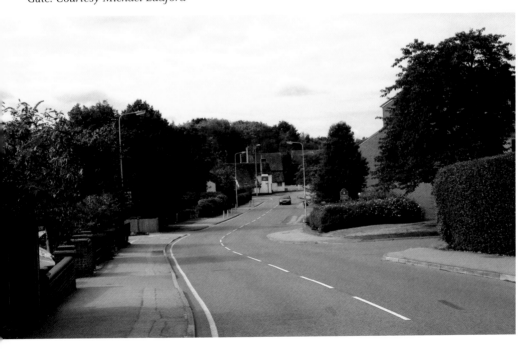

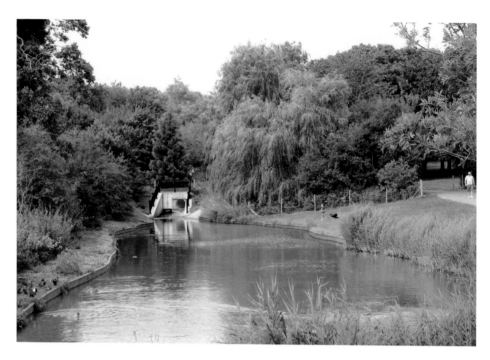

Fairlands

Originally, it was planned to leave a belt of working farmland running through the middle of the estates of the New Town. Fairlands Farm, at the top of Sish Lane, took over land from other farms, as its own fields around Pin Green were built on. Eventually, farming proved impractical and at the end of the 1960s, the farm ceased to be a working one. An ambitious scheme for a vast public park was put into operation, including two large lakes, and Fairlands Valley Park was opened in 1972. Thirty-six years after the farm buildings of Fairlands were demolished, the park has blossomed in every respect. *Stevenage Museum/P5320*

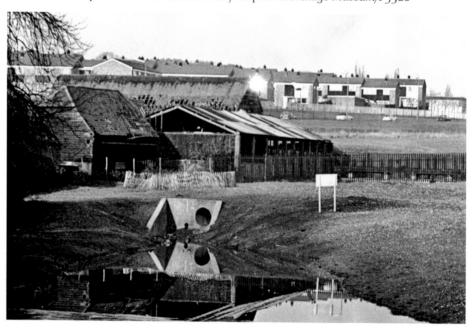

Donkey's Whim

South of Fairlands Farm along the track called Fair Lane, stood a pair of cottages built at the time of enclosure in the mid-nineteenth century. Always called New Farm on Ordnance Survey maps, these cottages, converted into one long ago, were known colloquially and even postally as 'Donkey's Whim'. They are seen *c*. 1930 when inhabited by the Stevens family. If they had survived today then perhaps Lakeside would be a better name. *Stevenage Museum/PP26*

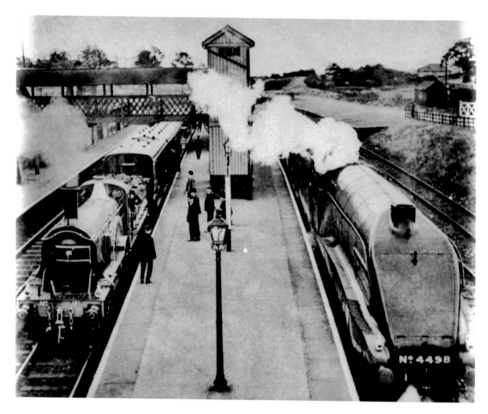

The Railway

The opening of the railway in 1850 may have ended the coaching era, but Stevenage went from strength to strength thereafter. In 1938, celebrations for the fiftieth anniversary of the 'Flying Scotsman' train brought Great Northern Railway 'Stirling Single' No. 1 to Stevenage with a train of six-wheel coaches typical of 1888, and the very latest in locomotive design in the shape of 'A4' class No. 4498 *Sir Nigel Gresley* with a train of streamline stock. Remarkably, thanks to the efforts of the A1 Locomotive Trust, it would be possible seventy-one years later to photograph a brand new 'Pacific' locomotive at the same spot as *Tornado* sped northwards. *Stevenage Museum/P2053*

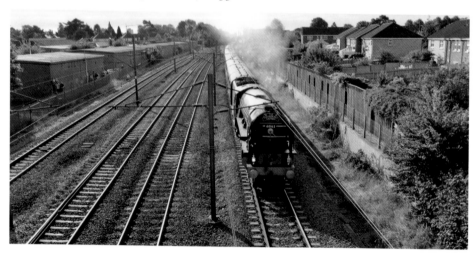

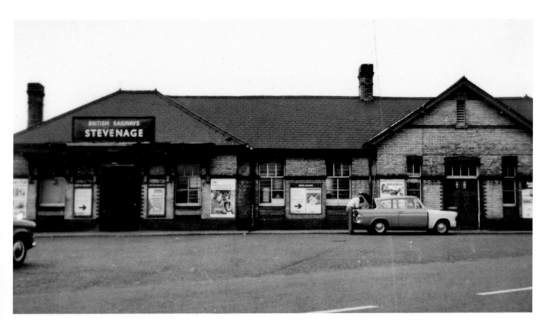

The Railway *(continued)*

Stevenage's second railway station, built in Julians Road a few yards north of the original facility when the line was expanded to four tracks at the end of the nineteenth century, was replaced by another, more central to the whole of Stevenage, in 1973. The old station entrance is seen on 22 July 1973, the last day before closure.

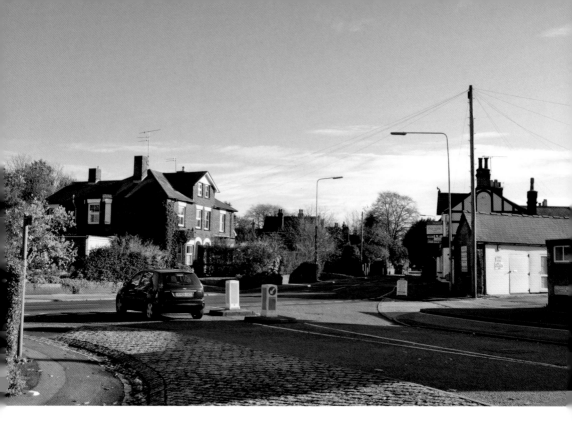

Julians Road

Julians Road takes its name from Julians Farm, whose yard is today occupied by Lincolns Tyres. Large houses and two pubs were built here after the railway opened. At the time of writing, one of the pubs, the Rising Sun, seen here, was closed; hopefully it will reopen.

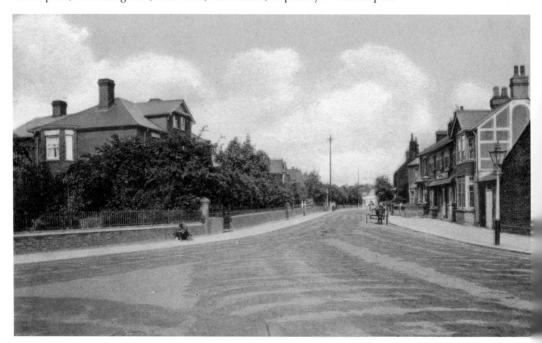

Julians Road *(continued)*

At lunchtime and teatime there would be a surge of workers from the ESA, mainly on bicycles, heading back into the town along Julians Road. They are pictured here in 1967 preparing to head out of Julians Road into Hitchin Road. This could not be undertaken today owing to the northern end of Road 10. *Stevenage Museum/TM35*

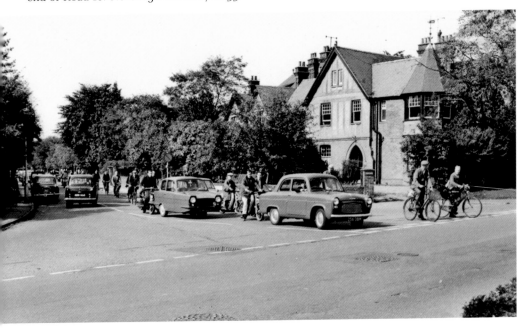

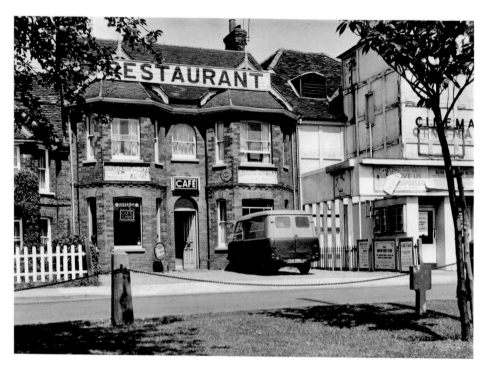

Bowling Green

The first call for many coming down Julians Road from the station was Tooley's restaurant at No. 4 Bowling Green. This was conveniently next door to the town's first permanent cinema, which in its latter years was called the Publix. Already closed by 1962, when the upper view was taken, it and some cottages were replaced by three houses in the late 1970s, one of which was home to the Bard of Salford, John Cooper-Clarke. *Stevenage Museum/PP606*

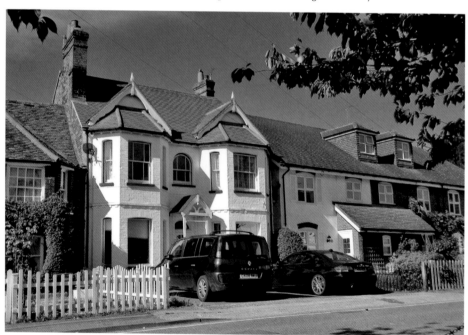

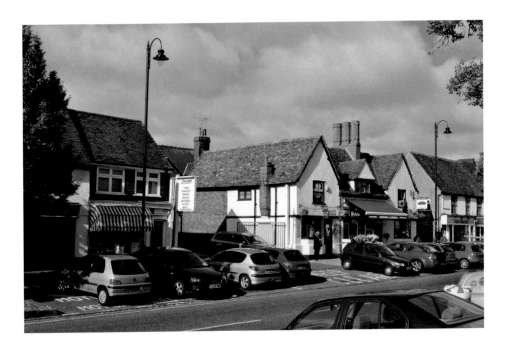

High Street, West

The west side of the street contains many old buildings, having never suffered the major outbreaks of fire that afflicted the other side of the road. Buckingham's hairdressers and Shelford & Crowe started in each of a pair of one-and-a-half-storey cottages. Buckingham's was rebuilt with a new upper storey between the wars, while the Shelford & Crowe cottage became a small showroom. By 1962, when one of the last new Ford 100E Populars is seen inside, the building's days were numbered. *Stevenage Museum/PP593*

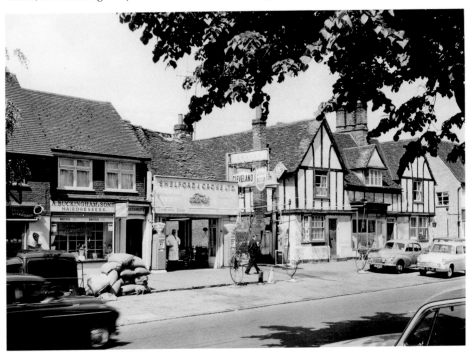

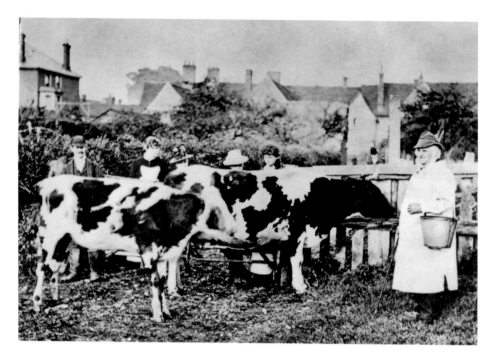

Behind the Red Lion

James Cooper, licensee of the Red Lion from 1868 to 1891, with his cows in the meadow behind the pub. This view illustrates well the changes of the Victorian era; already the large hipped roof of London House, containing J. Green's department store, can be seen in the background. Soon, a new street of houses stretching back to the railway called Green Street would be built and Mr Cooper's field would become the garden of a villa (where, incidentally, actor Leslie Phillips would grow tomatoes during his time in Stevenage). Today, a car park occupies the site and Green's is Waitrose. *Stevenage Museum/PP43*

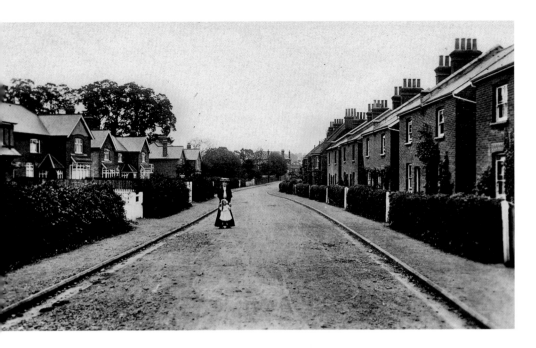

Green Street

Green Street was largely completed by 1910, although some houses would be built where the long brick wall can be seen in the interwar period. Green Street was severed by Road 10 in the 1970s; the wire fence is Lytton Way's 'central reservation'. The section leading into the High Street has been renamed Drapers Way, a reference to Green's.

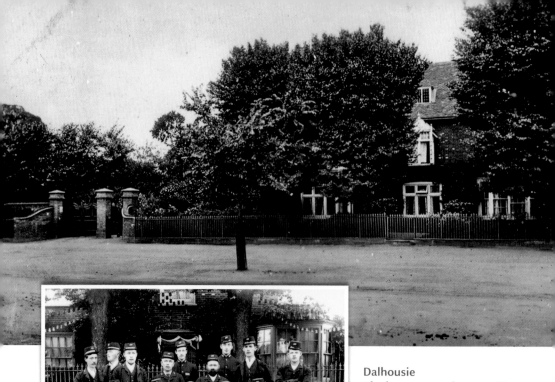

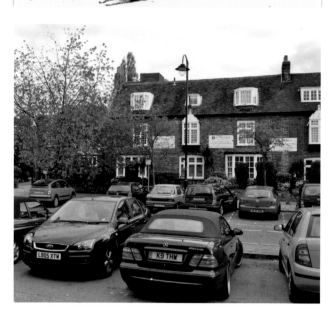

Dalhousie

The large private house at No. 25 High Street had more than one name before conversion to hotel premises. Known as Cromwell Lodge in the 1880s, it was in the early twentieth century called Dalhousie, recalling presumably Lord Dalhousie, Governor General of India. Unproven claims have been made that the building dates back to the sixteenth century and has connections to John Thurloe, Secretary of State and spymaster to Cromwell during the 1650s, but the building displays no evidence of being earlier than the eighteenth century and its site is probably just infilling of a wide open space formerly used for stock sales. Stevenage postmen pose outside the house, probably at the time of the Jubilee of 1887 or 1897.

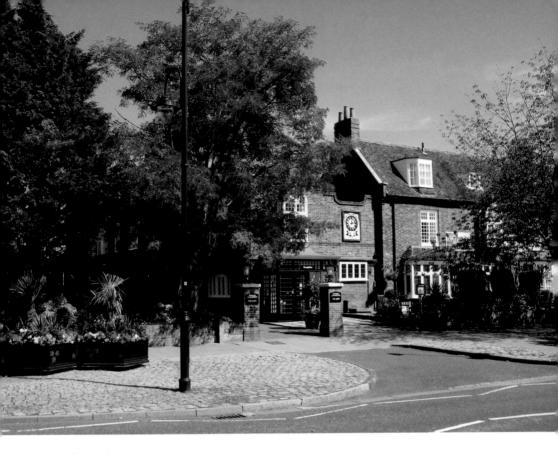

Cromwell Hotel

Having been the home of a stockbroker for some years, No. 25 High Street opened as the Cromwell Hotel in 1925. Acquiring an alcohol licence the following year, it expanded rapidly, a process that continued throughout the 1930s. An alpine rockery garden was created at the north end of the site by renowned local nurseryman Clarence Elliott and, eighty years after the Swan posting house had closed, the White Lion Hotel was once more outclassed by a grander rival. The police station in Stanmore Road, built during the First World War, can be seen in the background.

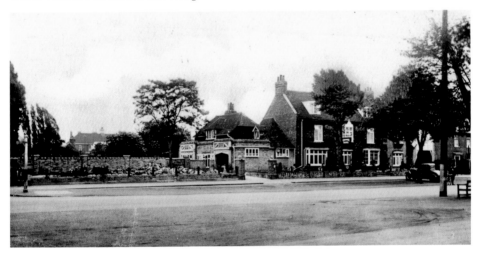

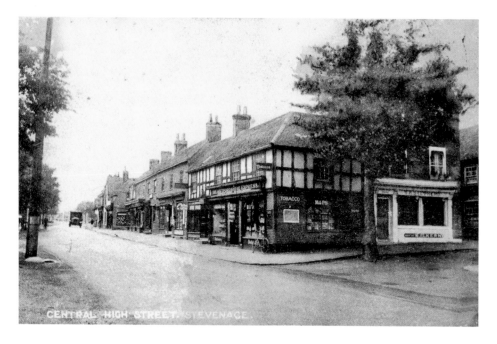

Middle Row

Just as all medieval high streets invariably tend to be wide expanses suitable for holding markets and fairs, so do they tend to have islands of later infill. Stevenage is no exception, with its Middle Row. Created as two islands of buildings bisected by what is now Baker Street, evidence from the buildings of the north island suggest that Middle Row was put up in the sixteenth century. The south island, seen here, had burnt down in the great fire of 1807; the building closest to the camera was put up in 1814 and was a Baptist chapel until the building of Albert Street, when it was replaced by the Ebenezer Baptist Chapel.

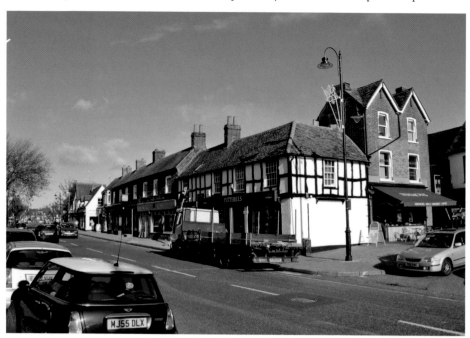

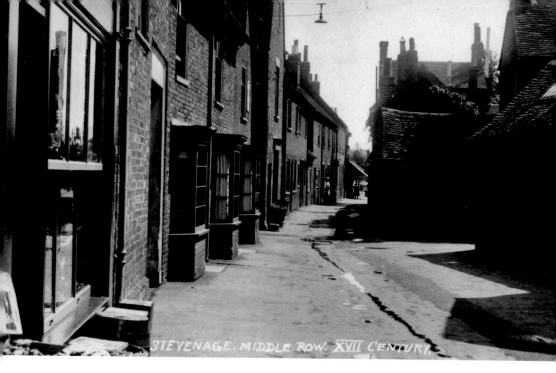

STEVENAGE. MIDDLE ROW. XVII CENTURY.

Middle Row *(continued)*

In 1910, when house numbers were introduced in Stevenage, Middle Row changed from being two islands of buildings into a street. This change meant that the buildings on the left, whose address was formerly 'High Street', were henceforth considered to be part of Middle Row, while those on the opposite page 'moved' to the High Street. The lower view was taken during the first Middle Row Day, held to coincide with Stevenage Farmers' Market.

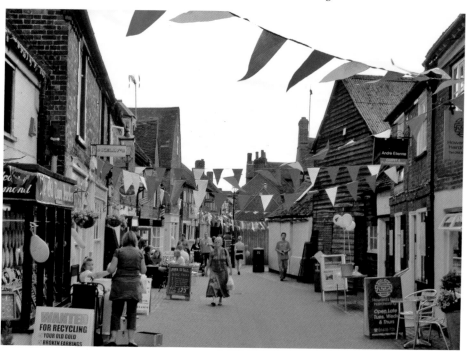

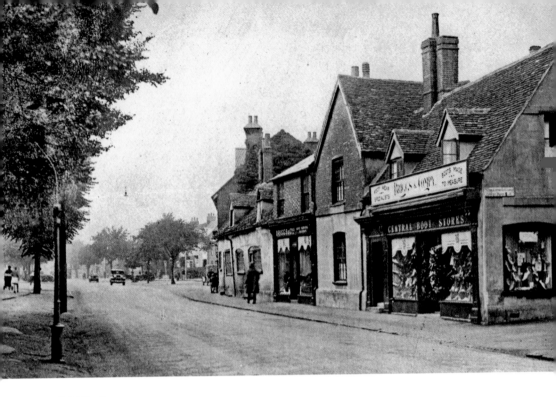

Middle Row

The north 'island' of Middle Row seen from the High Street side. The building nearest the camera is of typical sixteenth-century hall-and-cross-wing pattern, although much altered over the years. The one-and-a-half storey cottages were demolished in 1938; one of them was the home of Stevenage's last town crier.

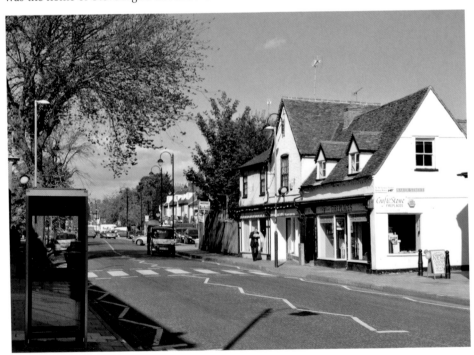

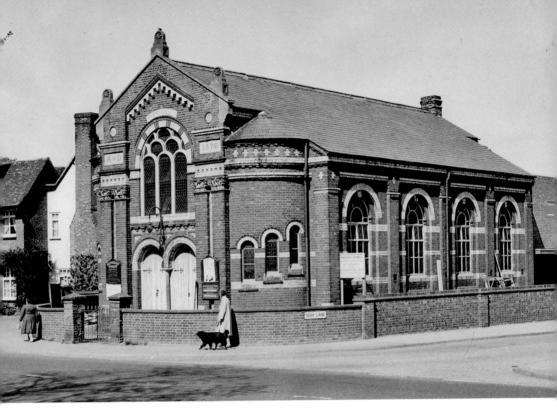

Methodist Church

Stevenage's Methodist church was built at the very south end of the High Street in 1876. In the upper view, taken in 1962, it retained its full Byzantine decoration; it made an appearance in the X-rated film *Serious Charge*, in which Cliff Richard made his big screen début. The same film also included footage of the town's previous Methodist chapel, then electricity showrooms and today the High Street library. *Stevenage Museum/PP626*

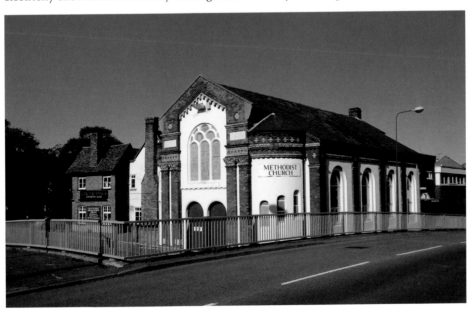

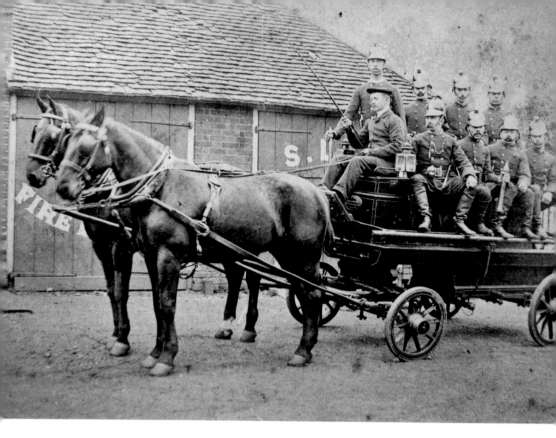

Bath House

In 1835 a 'fire engine house' was built on to the side of the Hellard Almshouses in Back Lane. This was the home of the town's hand-operated fire engine until 1910 when a Shand Mason engine was purchased. Basils Road was built immediately to the right hand side of the building, where the picket fence can be seen in the upper view. The 1835 building was then used as public baths from 1913 to around 1960; it has been magnificently restored and is regularly opened to the public. *Stevenage Museum/P12655*

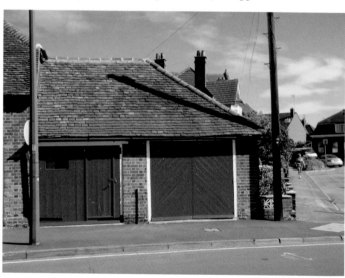

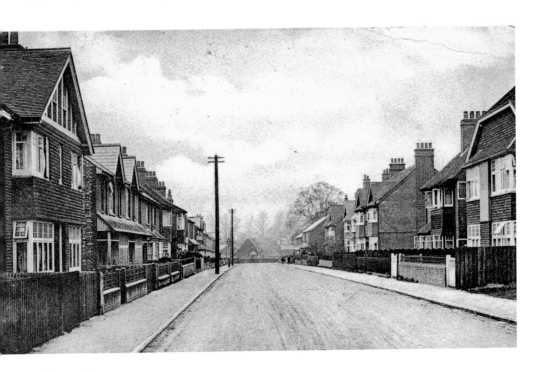

Basils Road

Basils Road is part of the Basils Estate, a significant expansion of the town in the first decade of the twentieth century, which also included Stanmore and Grove Roads. The upper view, a postcard published by T. Briden & Son, ('Stevenage's first department store') and posted in 1907, shows the street largely completed, although Nos 45 and 47, the latter being the home of Town Clerk Arthur Primett, have yet to be built.

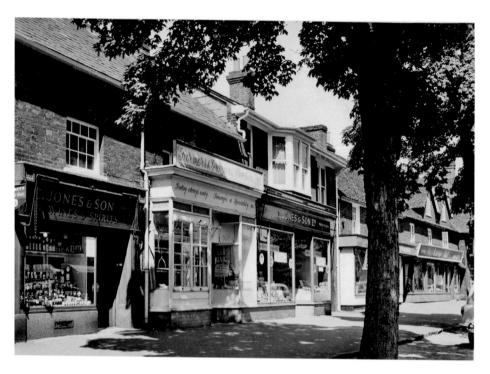

High Street Views

The west side of Stevenage High Street contains many old timber-framed buildings, which have been refronted in brick over the years. In the upper photograph, taken in 1962, the wine shop of C. Jones & Son at 120 High Street and the butcher's shop of Farmers & Graziers next door are good examples of this – the main, grocer's, shop of C. Jones & Son at 116 High Street was another such building before being rebuilt in the early twentieth century. *Stevenage Museum/PP591*

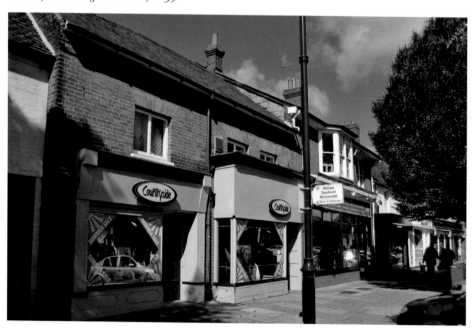

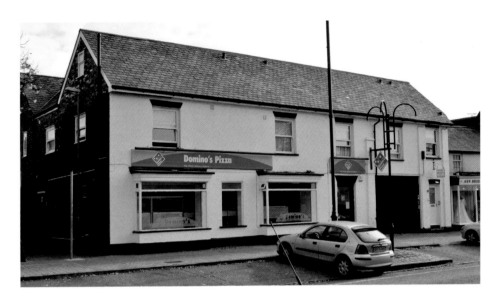

High Street Views *(continued)*

In the early twentieth century, this building was the home and works of Nathaniel Hodgson who achieved considerable repute for his patent knife grinder.

Matthews printing works was at the rear and publications such as the Stevenage & District Chamber of Trade's monthly *Everybody's Business* were produced here. By 1962, Palmers newsagents were thriving here; later the whole building would be the offices of Stevenage Printing. Considerable rebuilding took place in 2007. *Stevenage Museum/PP621*

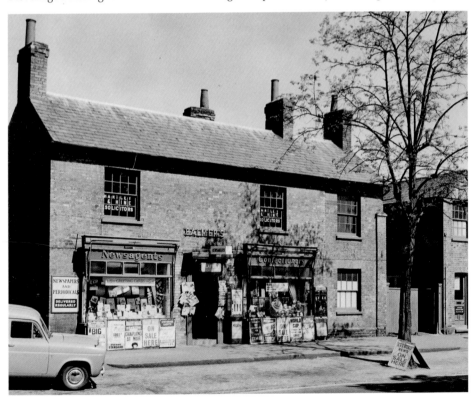

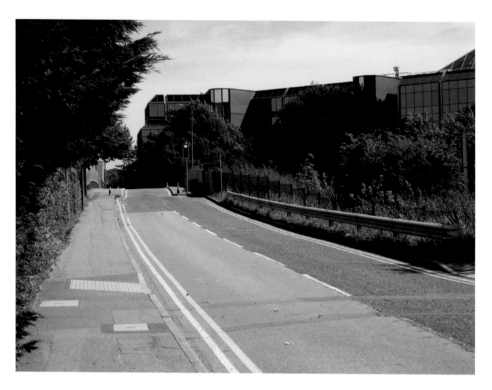

Chequers Bridge Road

Two new bridges were built over the railway at the start of the twentieth century, opening up the way for expansion to the west. Both were named after licensed premises. The southernmost, Chequers Bridge, replaced the level crossing at Trinity Road/Brick Kiln Lane, and Chequers Bridge Road was built westwards from London Road, to link with what would become Fairview Road. In the forty-odd years since the 1960s, almost every thing has changed – even the granite kerbs in the foreground have gone and The Icon building looms large over the railway. *Stevenage Museum/H14*

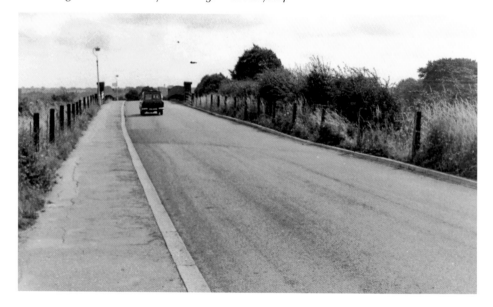

Bridge Road

The northern of the two bridges was on a new road headed away from the High Street through the site of the White Lion dairy. The White Lion Bridge did not give its name to the new road – a four-word street name would have been rather a mouthful – so the new highway came to be known simply as Bridge Road. The houses were demolished for the Road 10 scheme, which cut through Bridge Road. Today, the remaining stub from the High Street is called Bell Lane. *Stevenage Museum/P9*

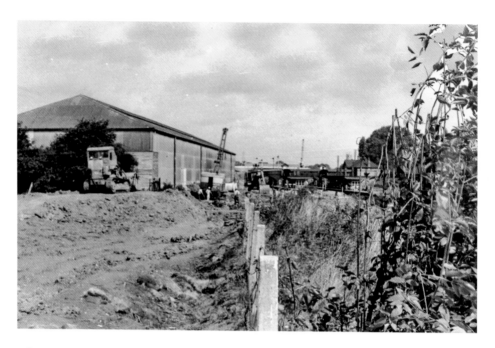

Hilton Close

In 1967, work was underway laying a new main sewer for what was described as the Fishers Green Development – the road of Scarborough Avenue. The location is off Fairview Road just south of the ESA storage shed. Everything in the 1967 view has gone or changed, except the Gunnels Wood Road bridge seen as a white line on the horizon and even that is obscured by tree growth, as is the railway. Today, the houses of Mayles Close occupy the site of the ESA shed, while Hilton Close takes up the foreground. *Stevenage Museum/D16*

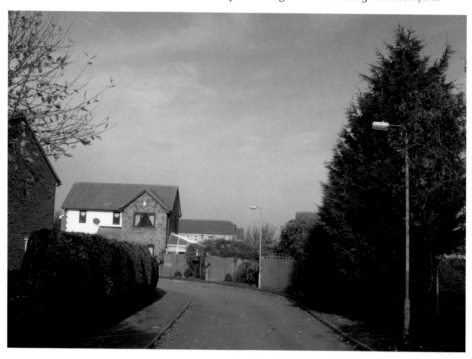

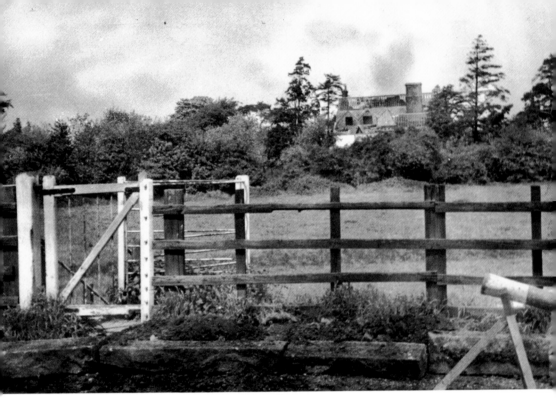

Orchard Court

John Bailey Denton was a very prominent figure in nineteenth century Stevenage. He organised the enclosure of Stevenage fields and extended The Avenue from the eastern side of Burymead to North Road. Commemorated in the name of Denton Road, he built a very large house, Orchard Court, in Orchard Road. After a period in use as offices for Stevenage Development Corporation, the house was demolished in 1958. Its grounds and one of the fields of the White Lion were used for the Orchard Court Estate – five new houses in Orchard Road and thirty-six in Orchard Crescent. *Stevenage Museum/P1323*

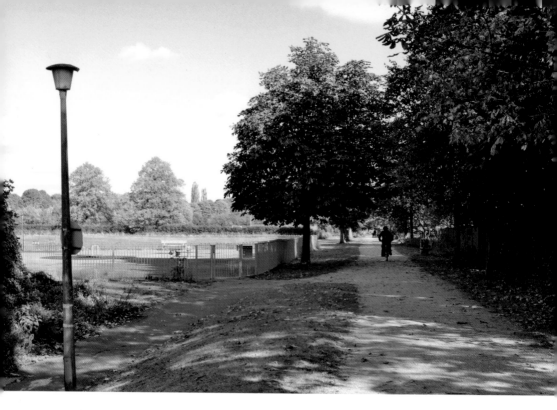

The Avenue

The Avenue is one of Stevenage's more attractive paths and its origins go back to 1756 when the rector, Nicholas Cholwell, planted two avenues leading away from the northeastern and southeastern corners of Burymead – one towards the then rectory, now the Priory, and one to connect with Church Lane. The latter was extended westwards alongside Alleyne's School 101 years later. This western extension is seen here, with part of St Nicholas infant schools (formerly the National Schools) just creeping into the picture on the left. The trees have been replanted after being blown down in the great gale of 1987.

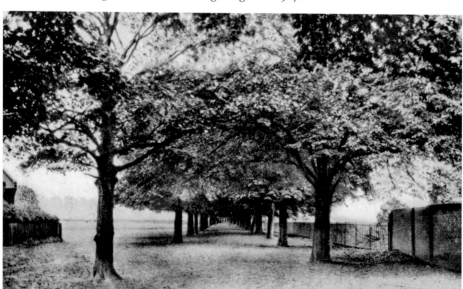

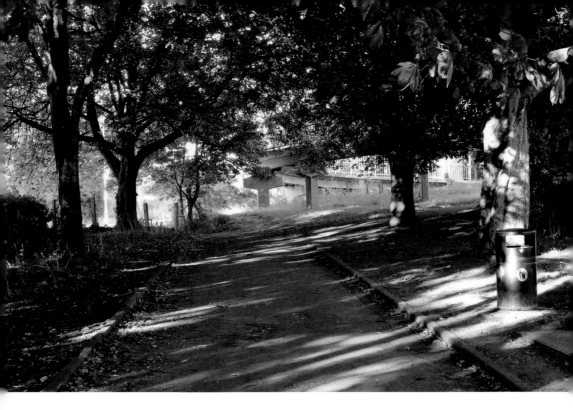

The Avenue *(continued)*

In 1935, the footpath from the eastern end of the original Avenue, which was the remnant of the old Church Lane, was planted with trees to mark the silver jubilee of King George V. Thirty years later, this Jubilee Memorial Avenue was cut in two by the construction of Martins Way. An interesting footbridge with a spiral approach was constructed to bridge the gap; this did not last and has since been renewed. *Stevenage Museum/C163*

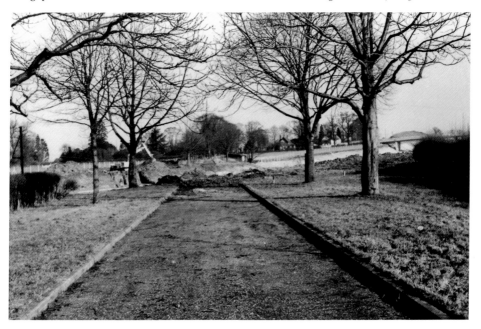

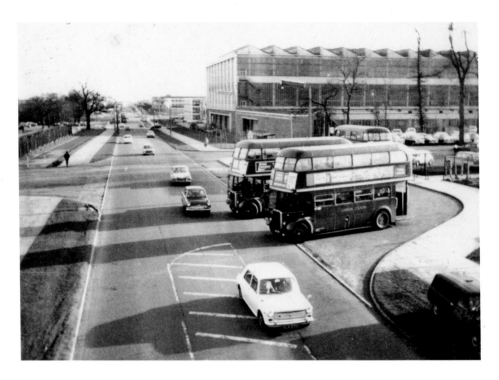

Gunnels Wood

Gunnels Wood Road is the main artery of the Stevenage Industrial Area, which has now itself been rebranded Gunnels Wood. In the early 1970s, a few trees of Gunnels Wood remained in the ICI car park, while bus services used the lay-by to turn round. Two RT type buses await a break in the traffic before turning south, while a third RT stands at the bus stop. The upper photograph is taken from a footbridge that spanned Gunnels Wood Road for a few years before it was turned into a dual carriageway in around 1975. The footbridge, which had started life spanning Graveley High Street before the (first) Baldock Bypass was built, was then re-used in Hitchin Road outside St Angela's School. *Stevenage Museum/T45*

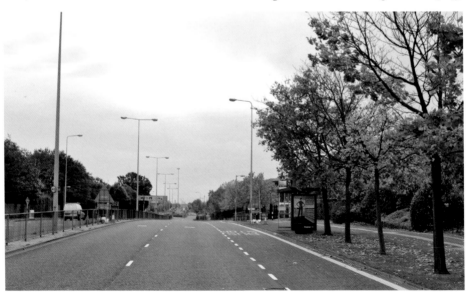

Renewal

Unusual building work being undertaken alongside Letchmore Green in 1976. Three houses were built where two had been before on the east side of the green, with the middle new house beginning to envelop the further of the pair of cottages as the latter start to be demolished. *Courtesy Mrs Pat Smith*

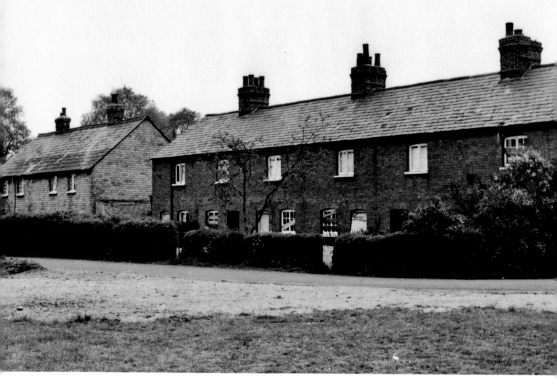

Ditchmore Common and Lane

Called Ditchmore Hall on Ordnance Survey maps, but always colloquially known as Ditchmore Common, these ten cottages looked eastwards over Ditchmore Lane on to King George V Playing Fields. Latterly owned by the Stevenage Development Corporation, the block nearest the camera did not have full-height partitions between the two bedrooms and provided a contrast to the SDC's thousands of brand new houses across the New Town. They were demolished in 1969. *Stevenage Museum/P5935*

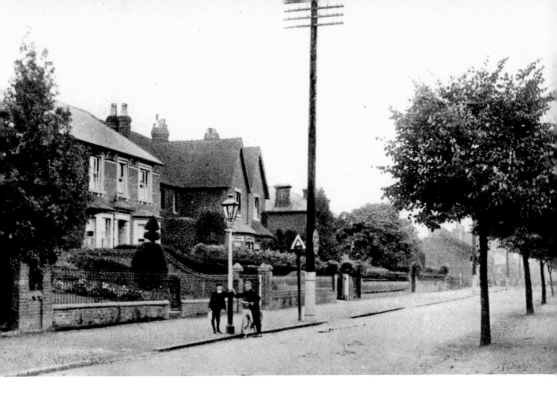

London Road

Once the railway had opened, Stevenage began to expand southwards along London Road. The houses there tended to be the larger type of villas. Most of the houses of London Road have been demolished, but those in these pictures have remained. London Road, however, has gone from here – this section of it was renamed after its side turning as Ditchmore Lane as part of the Road 10 scheme. The section north of the junction, with a truncated part of Chequers Bridge Road (itself renamed Gates Way) as far as the High Street proper, was also renamed 'High Street' at the same time, confusing people at the time and ever since.

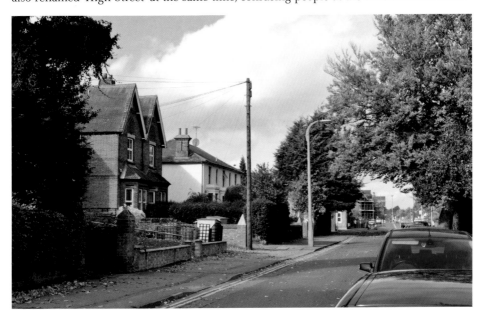

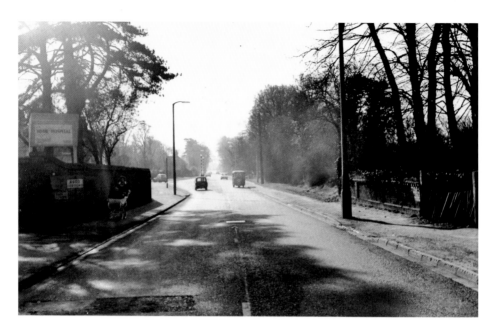

Danestrete Junction

When the New Town Centre was first built, its main access by road was from Danestrete. The northern end of Danestrete formed a turning off London Road, for which London Road was widened considerably. To provide good sightlines for motorists turning into Danestrete, the front garden of No. 7 London Road was cut back and the wall of No. 5 London Road – the Home Hospital for Women – was partly raked back. Forty-two years after the upper view, the northern end of Danestrete has long been built over, first by the Grampian Hotel and then by an extension of The Forum; this part of London Road has been obliterated and Nos 5 and 7 London Road are long gone, but the altered boundary wall (and a repair to the road in the foreground) remain. *Stevenage Museum/H78*

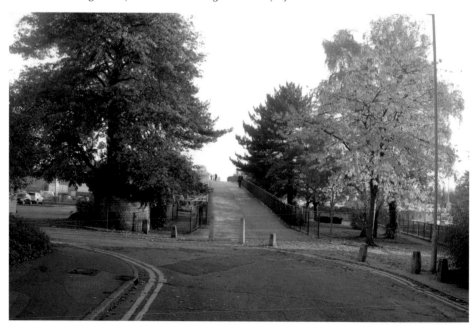

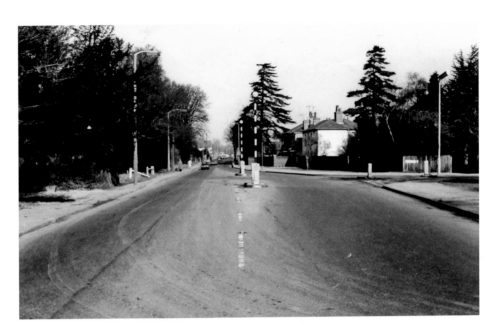

London Road

The London Road-Danestrete junction in 1967, looking north. The nearest building to the camera in the upper photograph is No. 7 London Road. This was called White Cottage and, from 1954, was the first home of Stevenage Museum. *Stevenage Museum/H81*

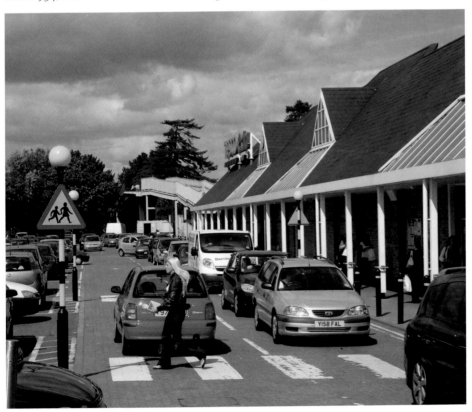

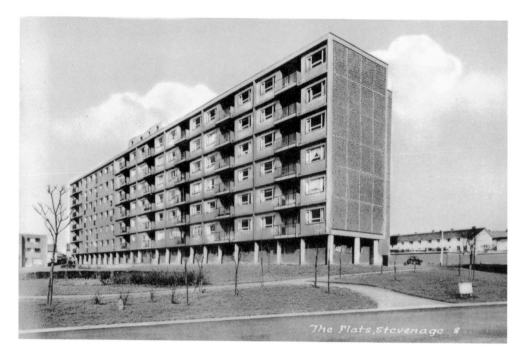

The Flats, Stevenage. 8

Stony Hall

The first estate of the New Town to be built was the Stony Hall development, whose centre piece was Chauncy House, a block of large flats intended for professional people. This building and its surrounding low-rise blocks were replaced over a period of several years to 2009. New housing was built alongside the existing blocks, which were then demolished.

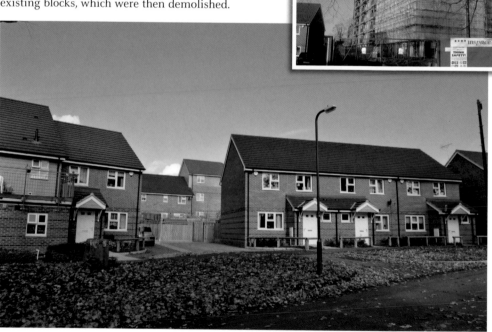

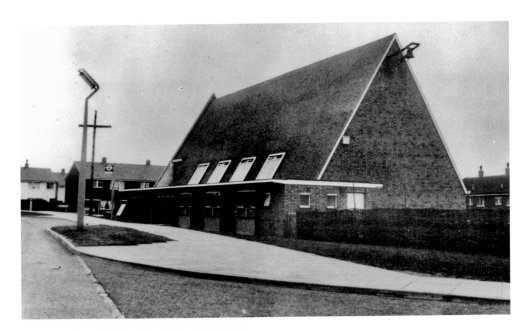

St Andrews

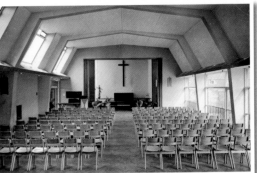

The first church to be built in the New Town was dedicated to St Andrew and was erected on Bedwell Crescent in 1953. It was destined for a short life and was replaced by St Georges Church a few hundred yards away on the periphery of the New Town Centre. Regular services ceased to be held at St Andrews in 1961. Used latterly by Stevenage College as a centre for teaching building skills, it was replaced by Harper Court, whose name recalls the first priest in charge at Bedwell, the Revd Ted Harper. *Inset, Stevenage Museum/PP163*

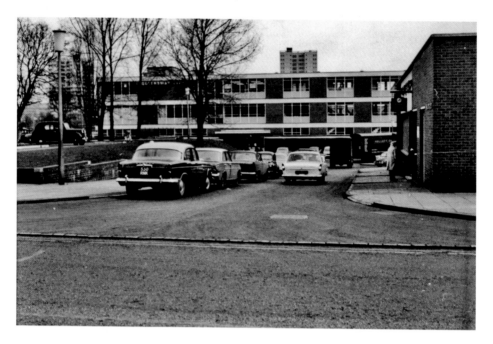

Westgate

Westgate is a small service road at the rear of Queensway, the main precinct of the New Town Centre. The upper picture shows it in 1967 with the tower block Brent Court newly-completed and Harrow Court (left) still under construction. Today, the Westgate indoor shopping mall obscures the view of Harrow Court from this spot. *Stevenage Museum/P26*

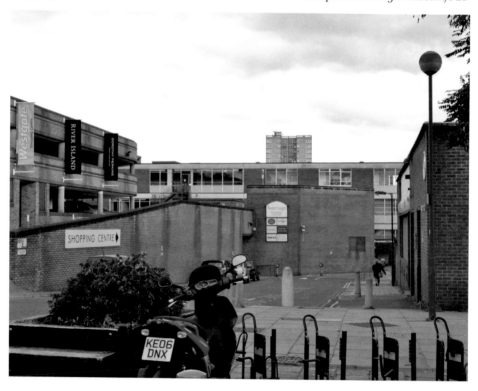

Westgate *(continued)*

The site office of Sidney Green, the contractor responsible for building the car parks and roads required for the second phase of the New Town Centre is seen in 1959. Fifty years later, at the same spot, one is inside the Westgate Shopping Centre, which was featured in name if not in reality in the Steve Coogan BBC sitcom *Saxondale. Neil Langdon*

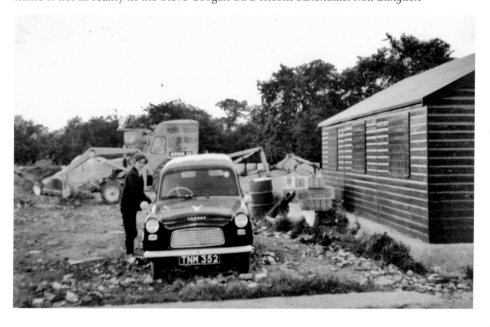

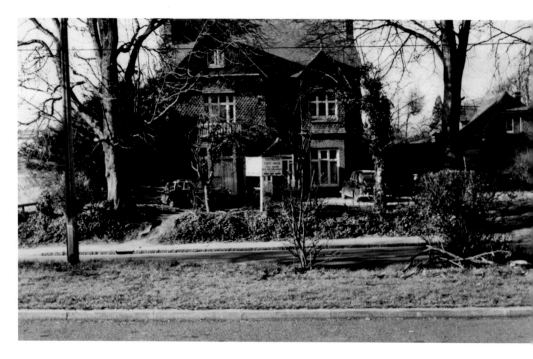

London Road

Southleigh Guest House, 50 London Road, in 1967. This was the southernmost of the large villas on the west side of London Road, standing next to the Stevenage Town football club for many years. The house was demolished shortly after the upper photograph was taken, to allow Swingate to be pushed back towards Lytton Way. *Stevenage Museum/H77*

London Road *(continued)*

London Road, looking south where Danesgate now crosses. The empty space on the right before the cottages is the site of the Our Mutual Friend, the pub named after Dickens' novel. The pub was open for ninety-nine years, before being replaced by another of the same name in Broadwater Crescent in 1963. Breaches Lane used to head west for Wilmore Common from here. By the time that the photograph below was taken, in 1967, the cottages were about to be demolished and within two years, Lytton Way would cut right across this Roman road roughly where the cottages stood. *Stevenage Museum/H87*

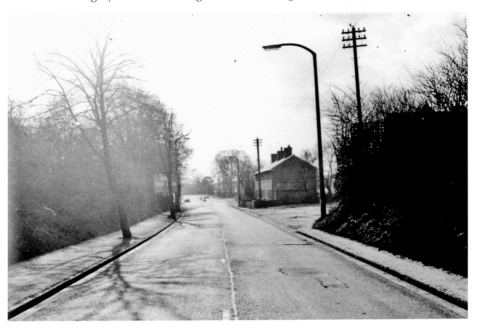

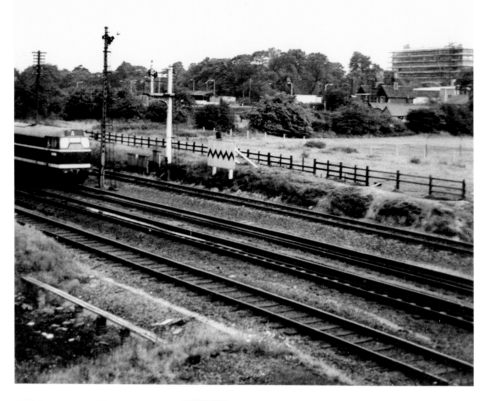

From Six Hills Way

The view across the railway from the west side of Six Hills Way Bridge. A then brand-new Brush Type 2 diesel locomotive heads a train south along the main line in 1959. The 'zigzag' sign at the trackside indicates the start of Langley Troughs, the famous landmark on the East Coast main line, where steam and diesel locomotives would pick up water while on the move (the latter required water for their steam heat boilers). Behind the railway, the old Stevenage Town football ground can be seen, while to the right are the twin gables of the pub Our Mutual Friend. In the background, beyond the concrete lamp standards of London Road, the office block Daneshill House is under construction. This would become the headquarters of the Stevenage Development Corporation and after that organisation's demise, it would become the offices of Stevenage Borough Council. Fifty years later, the same class of locomotive made a now very rare appearance at the same spot heading a structure gauging train. The large building just beyond the railway is the new police station. *Neil Langdon*

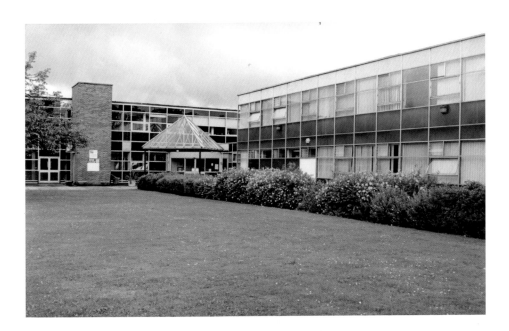

Stevenage College

Stevenage College of Further Education was built behind the Six Hills largely on the site of the nursery of world-renowned plantsman Clarence Elliott. It opened in 1961 and merged with Hitchin and Letchworth colleges to form North Herts College in 1991. Its site proved to be too attractive to resist turning over to retail use and a new college building a few hundred yards to the south was opened by HM Queen Elizabeth in March 2003. The former site of the college now hosts an ASDA supermarket, complete with a space in its car park marked out for the exclusive use of 2008 Formula One motor racing champion and son of Stevenage, Lewis Hamilton. *Neil Langdon*

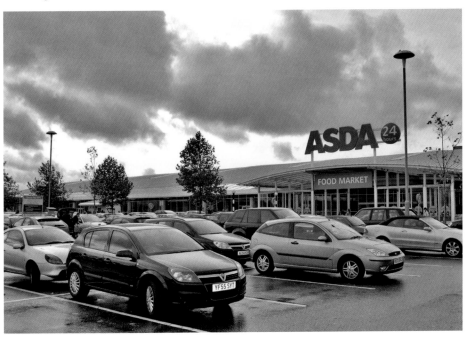

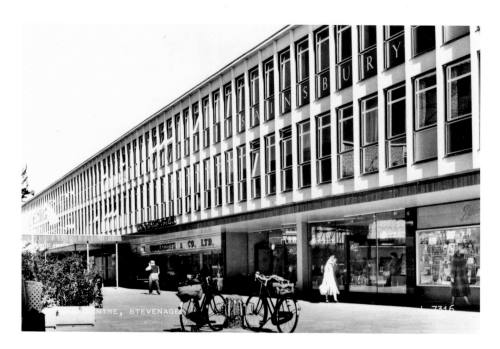

Queensway

HM Queen Elizabeth opened the first phase of the New Town Centre in 1959. To mark the occasion, the main shopping thoroughfare was named Queensway. This view shows the Woolworth store and the first Sainsbury's in the town. This latter lasted only about ten years before moving to larger premises when a new section of Queensway was built to the north. Half of this Sainsbury's was taken over by Woolworth's and half went to the neighbour on the other side, Boots the chemists. As this book went to press a branch of Wilkinsons was due to open in the former Woolworth premises.

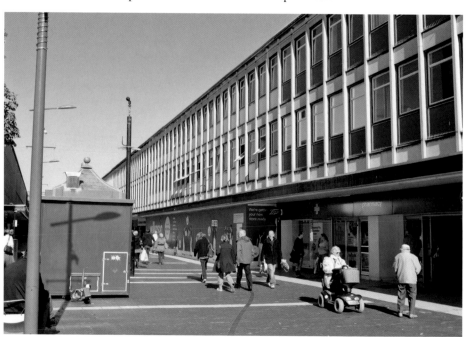

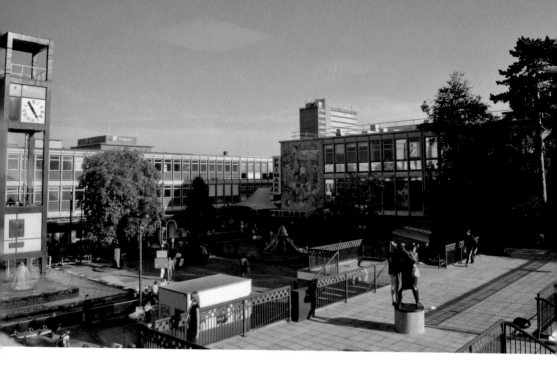

Town Square

The centre piece of the New Town Centre is Town Square, with its clock tower and sculpture *Joyride*. It is seen under construction in 1958 and again in 2009. Miraculously, a small horse chestnut tree from the gardens of Fieldview, the house which stood here before, still stands close to the clock tower. *Stevenage Museum/PP42*

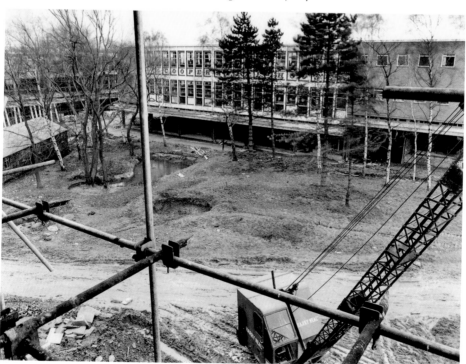

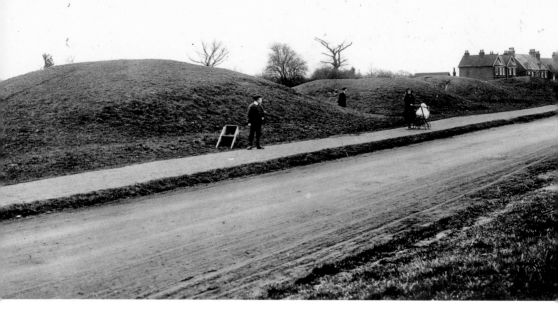

Six Barrows

Our journey finishes as it began, at the Six Hills. London Road, in the upper picture, is just a modestly sized highway though only a few years away from being dedicated as the UK's primary trunk road. Today, it has been rerouted round the east side of the Six Hills. The surviving stub of road on the west side, leading to a pair of office blocks, is today called Kings Road.

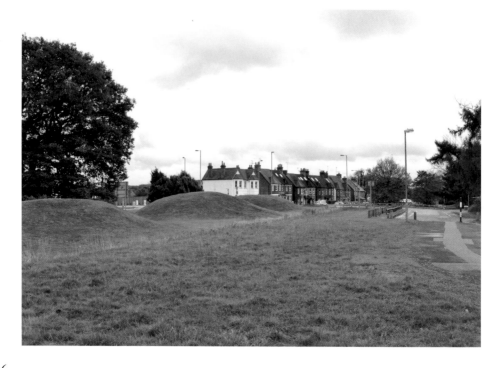